WATERCOLOUR
i n s p i r a t i o n s

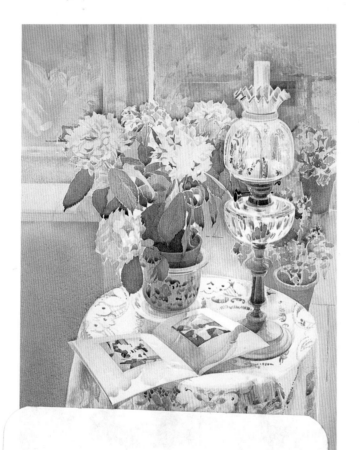

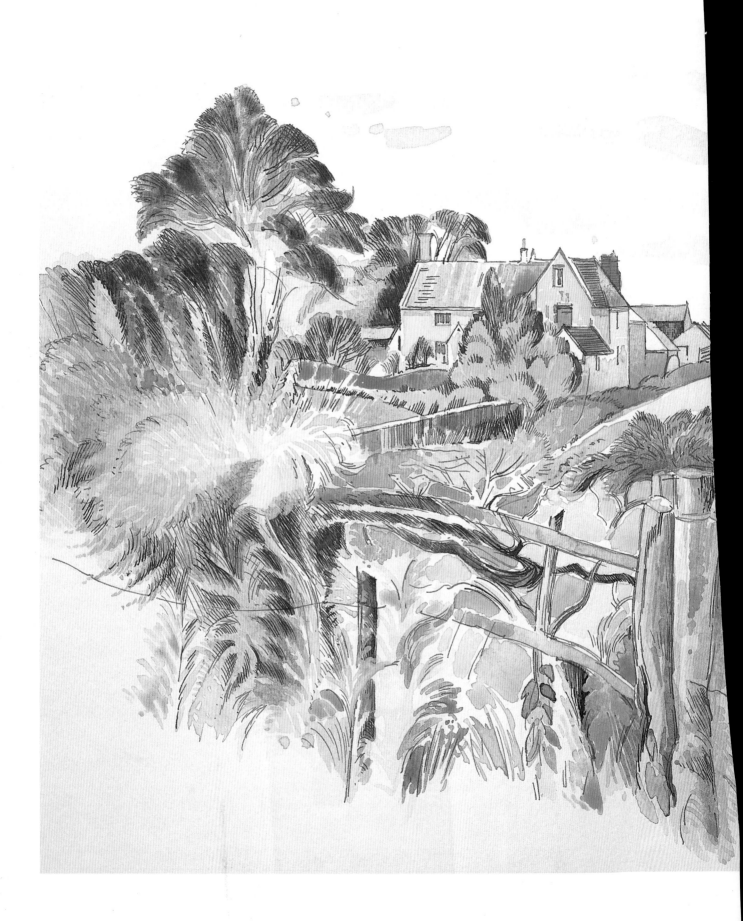

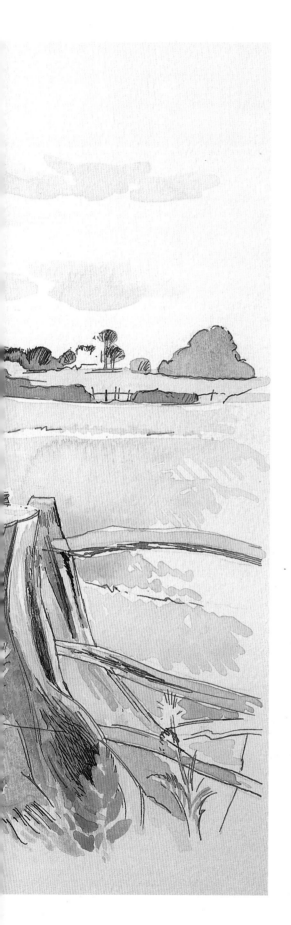

WATERCOLOUR
inspirations

DAVID EASTON

B.T. Batsford Ltd, London

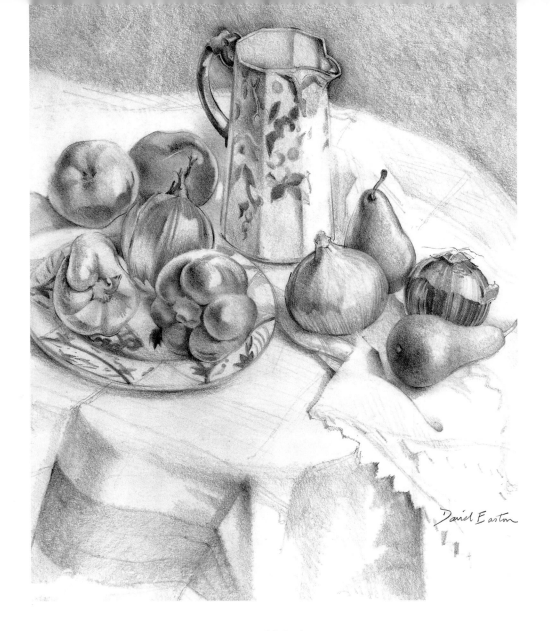

First published 1997

© David Easton, 1997

ISBN 0 7134 7242 1

A catalogue record for this book is available from the British Library.

Published by
B T Batsford Ltd
583 Fulham Road
London SW6 5BY

Printed in Hong Kong

Contents

Above Black Rock. Watercolour on tinted paper, 28 x 28cm (11 x 11in)

Introduction

The very word watercolour probably conjures up different images for us all, and applies to the works we have seen and appreciated, as well as our own experience of using the medium. It is probably true that there are more fixed ideas about acceptable methods of working with watercolours than with any other painting medium. I believe that this is unfortunate. Watercolours are there for us all to use in individual ways; the development of a personal mode of expression is what counts. It is part of my aim to extend traditional views about picture-making in a general way. The focus throughout this book is on learning to see through drawing with a range of media and implements; developing your knowledge of colour, and experience in its usage; and giving attention to the importance of pictorial composition.

Inspiration is the key to creative expression. While discussing what inspires me, I hope to pass some ideas on to you. Inspiration can be wide-ranging, but will usually involve an observed visual source. The subjects that I explore throughout this book are still life, landscape and flowers, with smaller chapters devoted to natural forms and imagination. This balance simply reflects the range of my own recent interests.

Drawing and painting are open-ended activities, and this fact can be confusing for the beginner. It is also a problem for seasoned artists considering the development of their work. It can be tempting to search widely for subject matter or for artistic styles. This may be fine for a while, but the mature artist will use a focused, personal style which has the potential to strengthen and develop.

I hope that this book makes a contribution to your enjoyment of painting in watercolours, and of drawing as well, and that you find a little needful inspiration on the way.

Chapter One

GETTING STARTED

This page is designed to put the following information about techniques into context. If you come to painting as a beginner, or indeed if you have lost direction as a painter, you might start by considering your situation. You might plan a course of action and identify fruitful starting points by checking:

1. Your circumstances – time and space for work at home, access to classes or art groups, transport, and fitness to travel.

2. Your interests – the landscape, townscapes, people, the garden, animals.

3. Your strengths – drawing, colour, imagination, patience, spontaneity.

Key Features of a Watercolour Painting

You may find it interesting to make a note of what you consider to be the key features of a painting before reading mine. I hope that the exercise proves to be thought-provoking.

In my view, the single most important attribute to discuss about any work of art is the composition. This means the overall design or the sum of all the parts. I might then

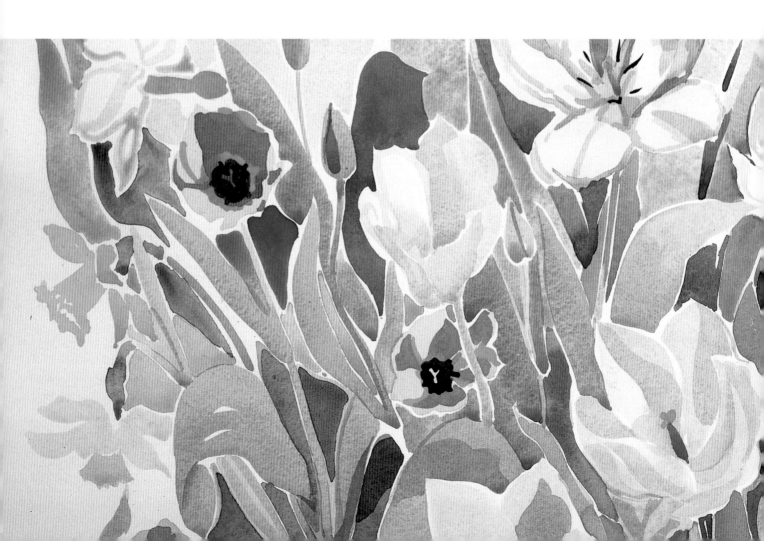

look for a good partnership between the chosen motif or focus of attention and the way the medium has been used to put across the idea. This idea could be the translation of an observed subject, or drawn from the imagination, or something which evolved as the work progressed. Drawing is an important factor in any work whether the subject matter is illustrative or abstract.

You will notice that techniques are not high on this list of priorities as I am firmly of the opinion that too much emphasis on this aspect of painting can inhibit originality. The techniques in this book should be taken as no more than points of departure for your own explorations. It is good to be aware of the potential range of the medium, which can itself be inspiring, but in my experience the traditional method of working wet-over-dry remains by far the most useful for the majority of artists.

Picture-Making

The ability to create pictures can be an instinctive gift which does not demand great theoretical knowledge. Most of us, however, have to work at it. I recommend that you use the still life format for some of your drawings and paintings. The degree of comfort, control and clarity gained in this situation enables you to focus clearly on the business of learning to paint.

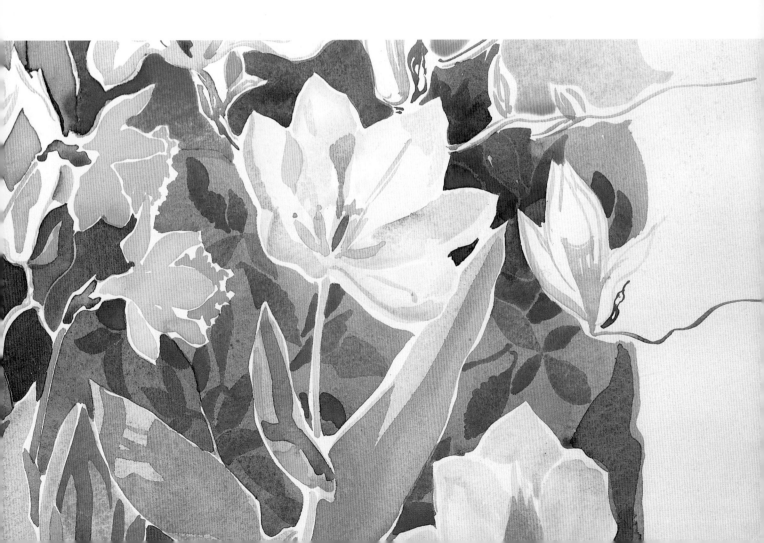

Chapter Two

WATERCOLOUR TECHNIQUES

WET-ON-DRY

Watercolours are essentially transparent when diluted with water. This attribute enables the artist to make use of the paper as the source of light. The painting process, therefore, consists of building the work from light to dark in a series of washes or smaller marks. When these marks overlap, two colours will produce a third. A similar colour can be achieved by physically mixing the two on the palette, and then applying the paint to the paper. Practising artists make use of both ways of colour mixing all the time, whether consciously or not. Any area of colour can be altered while it is wet. More pigment can be touched in to strengthen, warm or cool the colour. This technique is shown more fully on page 27. Avoid adding colour to any area that is damp.

You have to allow for drying periods before proceeding with your painting.

The first example on this page shows a simple pencil drawing to guide the subsequent work. The second illustration shows the first application of a cool wash of French ultramarine with a little light red. This is not an overall wash, but one which begins to describe shadow areas, while reserving the white of the paper. This could have been laid flat and even in tone, but it is more

constructive to make the colour begin to work, even at this early stage. You will notice that the colour varies in intensity and in the proportions of the two constituent pigments. This makes for a more lively effect.

The third illustration shows a further development. More colours have been added over a similar beginning. The wet-on-dry processes continue until the sketch is considered to be complete.

Pencil, actual size

Pencil and watercolour, actual size

Watercolour, actual size

BRUSH-DRAWING

Flowers lend themselves well to brush-drawing. These three examples are details from large flower paintings. Preliminary pencil work would have inhibited the flow while the brush marks express the flower shapes more eloquently. Brush-drawing should not, however, be confined to this type of motif; it has a much wider application, which includes using brushes of a very different shape, such as broad chisels or mops. The detail below is from a full-sheet painting of tulips which was made in the garden. The composition is very selective and explores light and movement. Muted colours have been mixed and applied with fluid touches, often placed between the flowers to key the light stems and petals. Yellows are glazed over some of the tulips with a broader brush.

Seen top right is a detail from *Irises and tulips* shown in full on page 91. It is an example of brush-drawing that is more about shape than line. The negative shapes are taken equally into account in the drawing process. The iris flowerheads are composed of French ultramarine, with touches of violet and cool red. Cerulean blue is used in the mix for the foliage.

Yellow pigments can present the artist with problems of tonality. They will tend to float on white and, in the detail shown below right from a painting of rudbeckias, I have organized other colours to key the lighter lemon yellows. The other yellows are of a deep enough tonality to read well. Brown madder passages in the petals were introduced while the warmer orange/yellows were still wet.

On many occasions I have found Naples and lemon yellows, and mixtures of the two, very useful for the initial drawing of a complex flower or still life motif. The colour becomes a natural part of the piece, without staining too strongly, and allows for flexibility and changes as the work progresses.

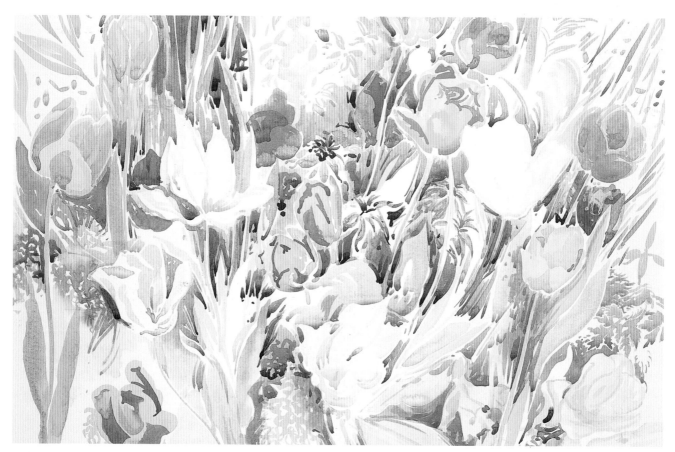

Tulips. Watercolour, 51 x 76cm (20 x 30in)

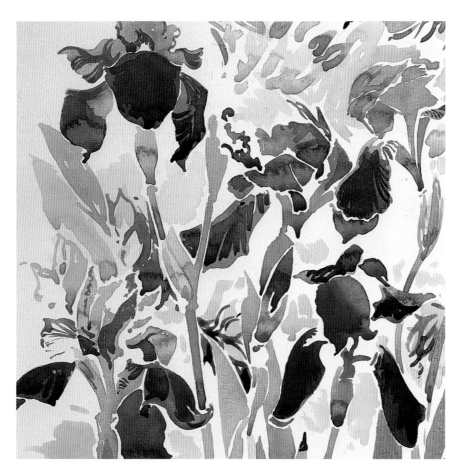

Irises and tulips. Watercolour, 51 x 51cm (20 x 20in)

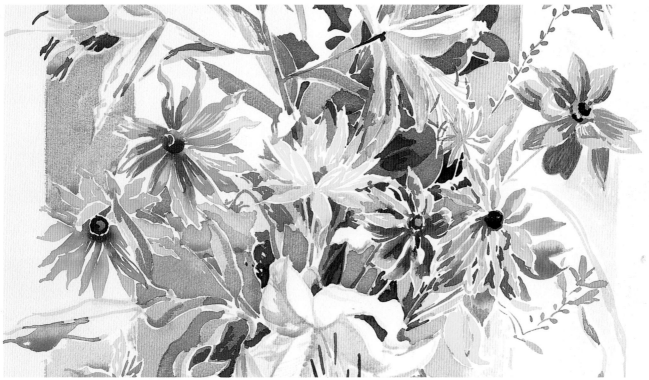

Lilies and rudbeckia. Watercolour, 66 x 51cm (26 x 20in)

LINE AND WASH

The function of line and wash is to provide a linear structure, which is then given colour or tonal values with transparent paint or inks. The line is usually provided by pencil or pen.

Little Stretton is sketched with a waterproof brown ink. Washes and touches of watercolour were then added over the fine line to note the light direction and to give some reference for the colours of the masonry. A constellation of rooks' nests enlivened the scene.

A vast range of drawing inks has become available to the artist. They open up all sorts of possibilities which I have hardly begun to exploit. In the small example shown below, the interplay between the lines in the two ink colours is developed with watercolour washes.

The study of narcissus opposite was drawn with a 0.7 push-up pencil. This fine lead encourages a linear style with little or no shading. Delicate washes of watercolour were laid in distinct shapes on the smooth drawing paper.

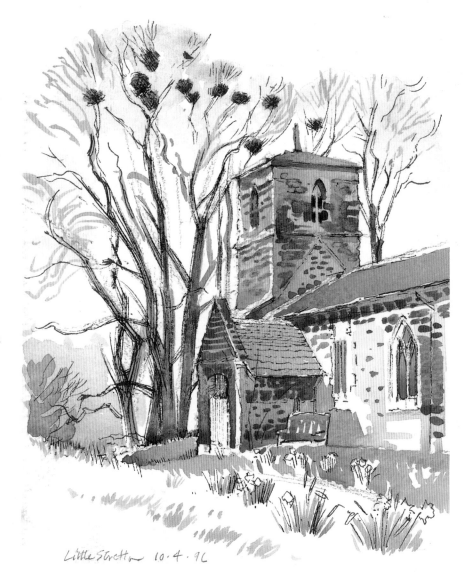

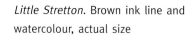

Little Stretton. Brown ink line and watercolour, actual size

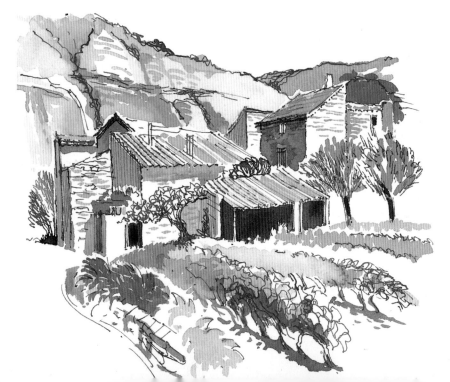

Ardêche Farmhouse. Acrylic inks and watercolour wash, actual size

Narcissus. Pencil and watercolour,
33 x 27cm (13½ x 10½ in)

David Easton

March '95

WET-IN-WET

I seldom regard wet-in-wet as a technique for painting a complete picture. This is because I tend to look for a degree of clarity in the shapes that play a major part in my work. Within these shapes a lot of wet-in-wet can be evident. You need to look upon them as islands of wet paint bound by dry paper.

This detail from a still life with a cyclamen plant shows that much of the foliage area has been flooded with colours which are closely related in tone. The area was given a yellow/green wash to start with, and it was at this stage that the flowerheads and the thin slivers of white paper, which give definition to some of the leaves, were reserved. This was done by leaving clear paper between some of the shapes, while applying the initial washes. Then blues, stronger greens and burnt sienna passages were added to the wet area. When all was dry, a few touches of richer colour completed the work.

Another example of wet-in-wet controlled within areas is the detail from the topiary garden painting opposite (complete painting on page 80). In this example, a simple set of gradations in wet paint forms the basis, when dry, for more brushwork.

Lilies and cyclamen. Watercolour, 63 x 46cm (25 x 18in)

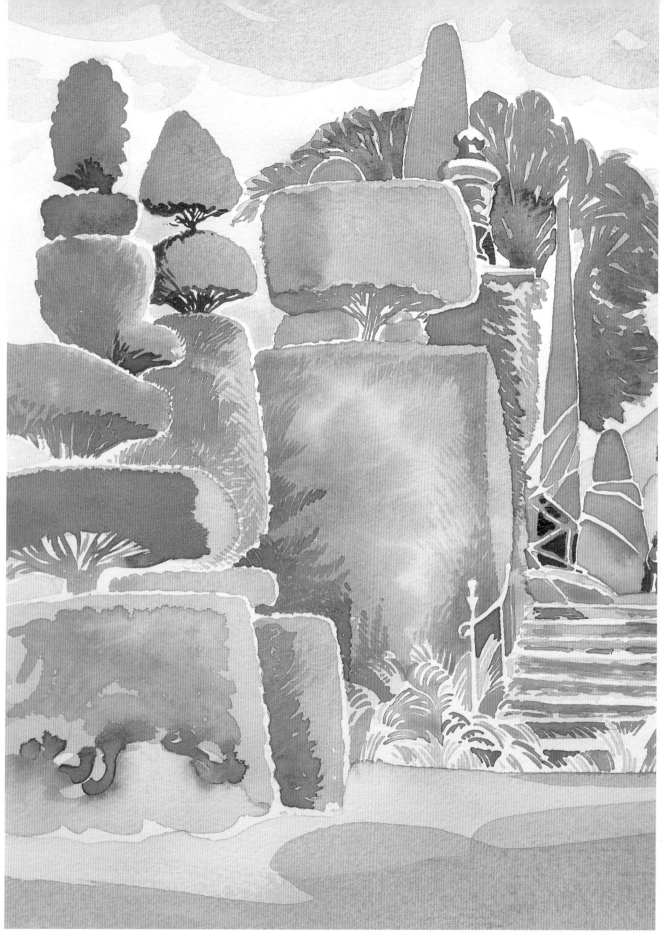

Topiary, Plas Brondanw. Watercolour, 33 x 33cm (13 x 13in)

OPAQUE PIGMENTS

The transparent quality of watercolour is its major attribute, but opacity should also be seen as a quality which can enhance a painting.

The painting of lilies on this page, a detail from *Lilies and pineapple* (shown in full on page 65), began with the preparation of a coloured ground on white paper, as described on page 62. Transparent colours were used for the deeper tones and white for accents. Diffused colour was then used to make slight adjustments to the whites. Some of the darkest details were added last of all.

Magnolias was painted almost entirely with white gouache, mixed with small amounts of watercolour pigment. The bright-blue pastel paper shows through the first semi-opaque white shapes, especially in the flowers at the base of the sketch. The flowers were built up with progressively lighter and more opaque colour.

Irises in the border was painted in the garden on grey pastel paper. The opacity is mainly provided by the yellow pigments Naples and lemon (nickel titanate), with just a little use of white gouache. Most of the foliage was painted with watercolour, with each colour gauged according to the tone of the paper showing through the transparent paint.

In the course of painting a watercolour by traditional means, you may need to reclaim an area that has become too dark by lightening it (i.e. painting over it with pigments that contain white); for this purpose, the use of opaque colour is just as valid as washing or scratching out the colour, and offers much more choice of colour and tone. I think it is essential, when on location, to concentrate on capturing your image by whatever means. You can concern yourself with pure technique in the controlled environment of the studio.

The painting on pages 20 and 21 is of my garden in autumn, viewed from the window. A full sheet of grey/brown pastel paper was taped, not stretched, on the board, as I did not envisage using washes of dilute colour. The richness of effect I sought would have been hard to achieve in watercolour alone. The paper provided a warm background and was helpful in producing natural-looking greens, which are notoriously difficult to achieve. Watercolour and gouache pigments, too varied and numerous to recall, were used in the work. The initial drawing was created with the brush, in tones darker than the paper. Having planned the basic structure, the painting progressed from dark to light. Several brush types were involved in giving variety to the foliage, which was painted with an awareness of directions of growth. A path leads into the lighter, more open, part of the garden, where our resident blackbird is in his favourite spot, very obligingly giving a sense of scale.

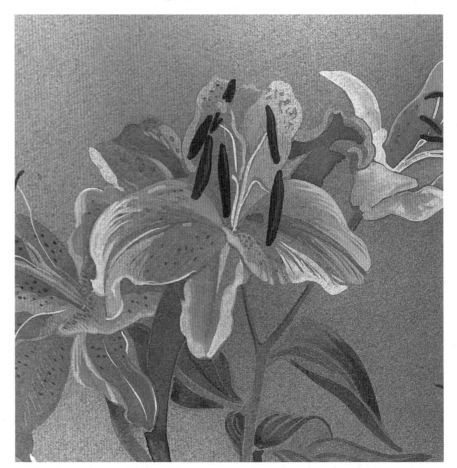

Lilies and pineapple. Watercolour and gouache, 54 x 54cm (21 x 21in)

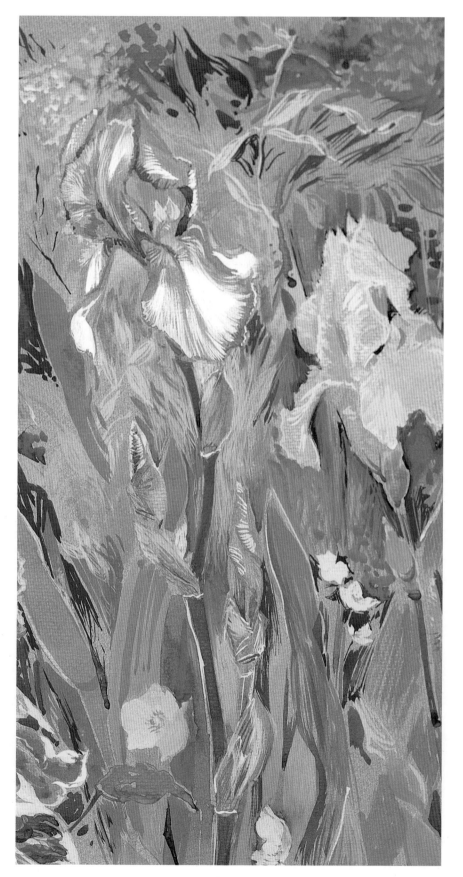

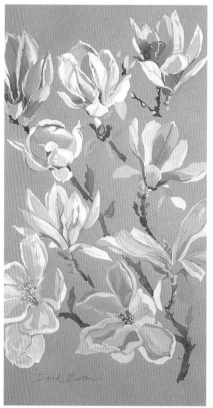

Magnolias. Gouache on blue pastel paper, 48 x 30cm (19 x 12in)

Irises in the border. Gouache on grey pastel paper, 51 x 30cm (20 x 12in)

(Overleaf) *The garden in October.* Watercolour and gouache on brown pastel paper, 51 x 66cm (20 x 26in)

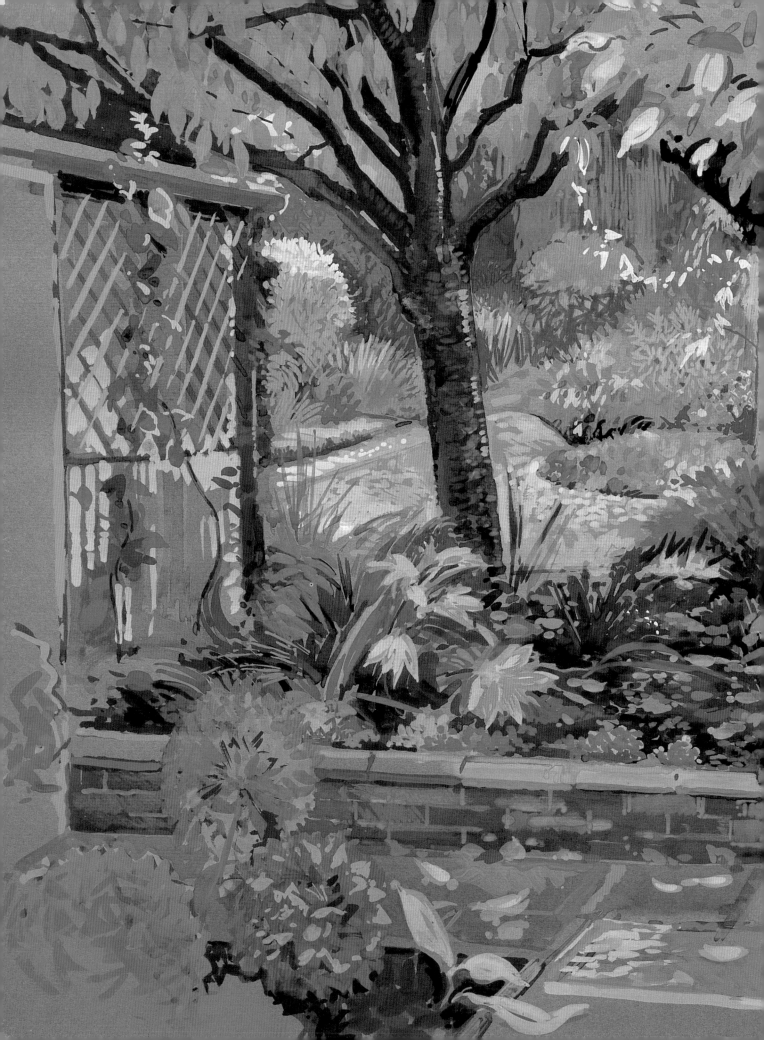

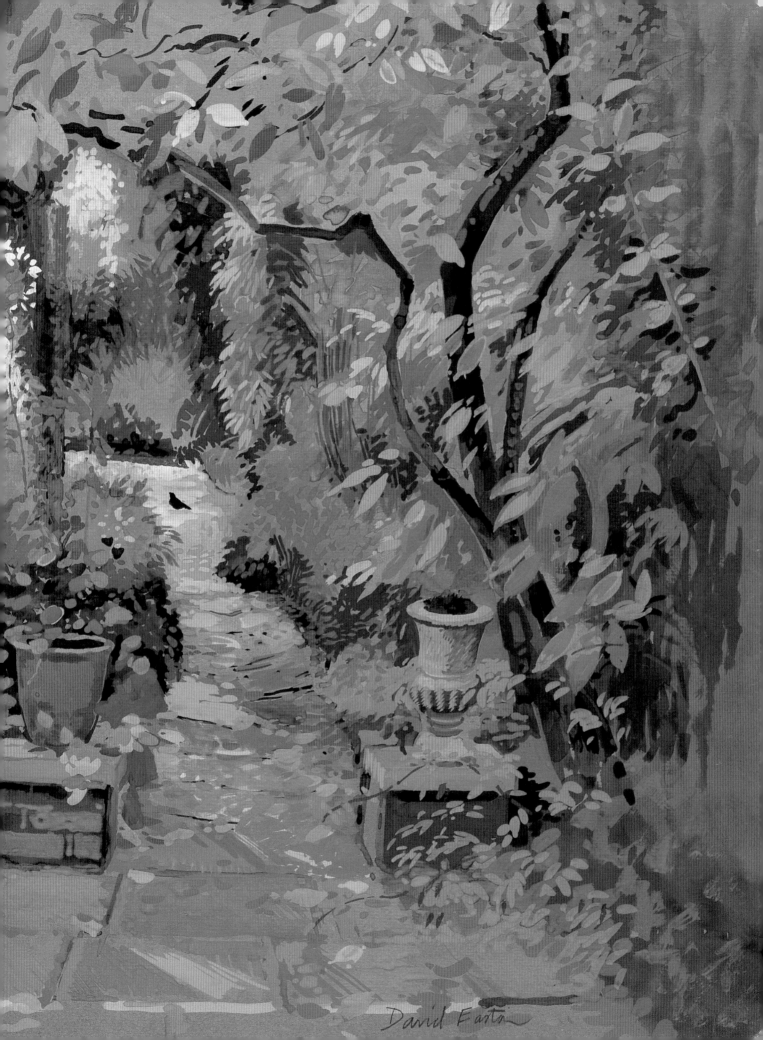

David Eastn

RESIST METHODS

There are several ways of preventing watercolour reaching certain parts of the paper and these are called resist methods. Masking fluid gives the artist the advantage of washing colour freely over the work while light shapes are reserved. When using it myself, which is very seldom, I prefer to introduce it after applying some washes of colour which gives a more subtle effect than masking to white. The method works best on hard and smoother papers as soft papers can tear as the dry fluid is removed. Apply the masking fluid with an old brush which should be washed with warm water and soap as soon as you have finished. Pens can be used for fine lines. The example below left has been masked two or three times to give a range of tones.

The second and third examples are chiefly about texture and ideally you would use them when seeking to create effects which are not too predictable or controlled. The landscape below right has candle wax

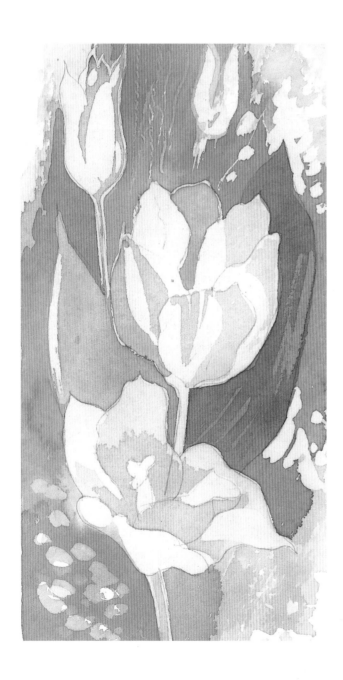

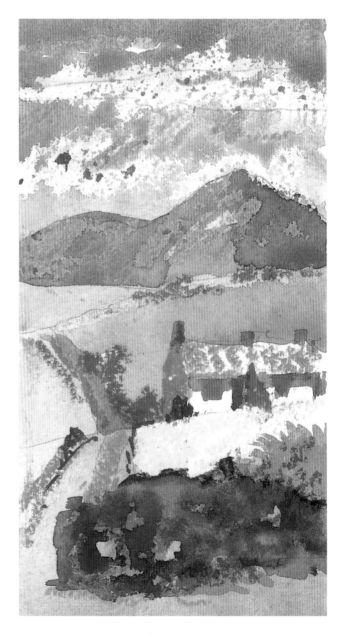

in the sky and touches of oil pastel throughout. Watercolour, varied in colour and strength, was washed over the whole area. When dry, the mountain shape was laid in, then the foreground wall was painted, and this received added pigment while wet.

In the old townscape shown below left, I prepared the paper with opaque areas of whites and creamy yellows which were allowed to dry before watercolour was applied selectively. Waterproof inks or dilute acrylics can be used in a similar way.

The small piece below right shows the result of protecting parts of the paper with a mask or stencil which can be cut from paper and then diffusing colours one by one; this was done on top of a light wash. The technique is shown on pages 63–65. I used an old style fixative diffuser for this series of four images, usually to adjust the colours of a conventional wash. You could obtain coarser textures from a splatter technique using a bristle brush.

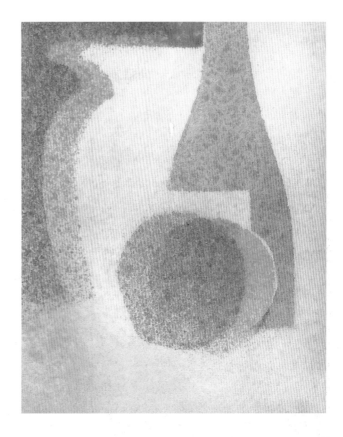

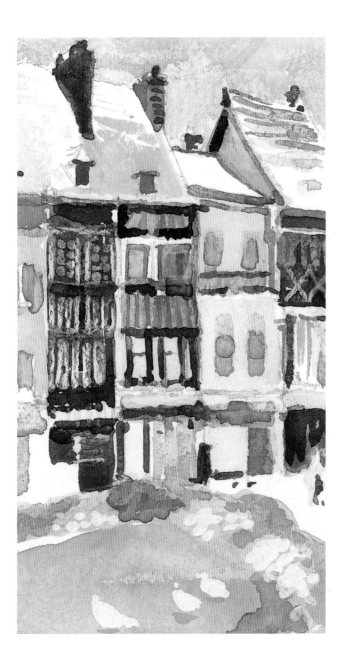

TRADITIONAL METHODS IN ACTION

Transparent wet-on-dry techniques can, of course, form the basis for most of your work, as they do for mine. They can also be combined with the many other methods you will find on the following pages. Before looking at these, however, I show a series of details from paintings illustrating the traditional use of the medium. These paintings do not feature expansive washes, which would also be traditional, but they each show my shape-by-shape style and often employ the strategy of leaving areas of dry paper to give a sparkle between the colours. This

detail from *Spring border*, which is shown in more detail on pages 8 and 9, illustrates the build-up of shapes with cool washes which establish the pattern of the subject. The colour is a simple analogous scheme, with some contrasting warm accents.

Shown top right is a detail taken from a sketch made rapidly on the spot in southern France. The colours are similar to those in the flower painting, but this is rather more spontaneous. The warm areas and the cooler ones are simply grouped to give the impression of sunlight and reflections in the shadows.

Below right is the central section of *The garden in May*, which is shown complete on page 86. Several brush sizes and types have aided the diversity of scale and shape in the foliage forms. Washes pull the work together here and there, but small patches and slivers of blank paper still play a part in the scheme. This is seen in the blossom tree, the white paintwork of the house and the horizontal light across the grass. Ample drying times between each session enabled some much needed clarity to be found in the complex foliage forms.

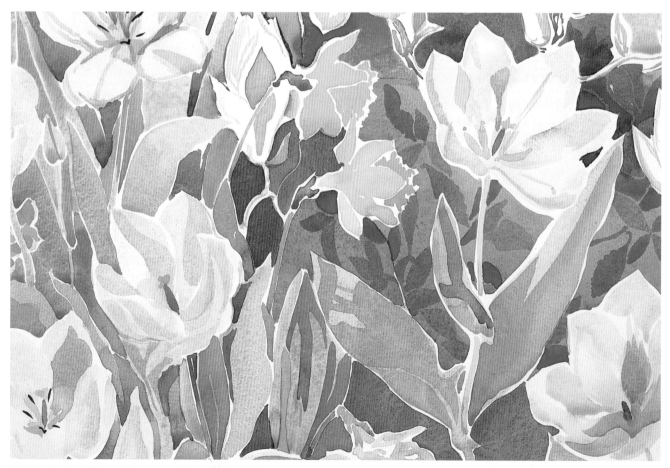

Spring border. Watercolour, 51 x 66cm (20 x 26in)

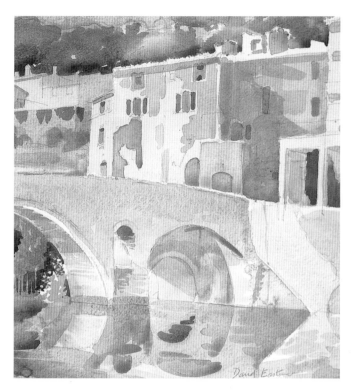

Sauve. Watercolour, 30 x 38cm
(12 x 15in)

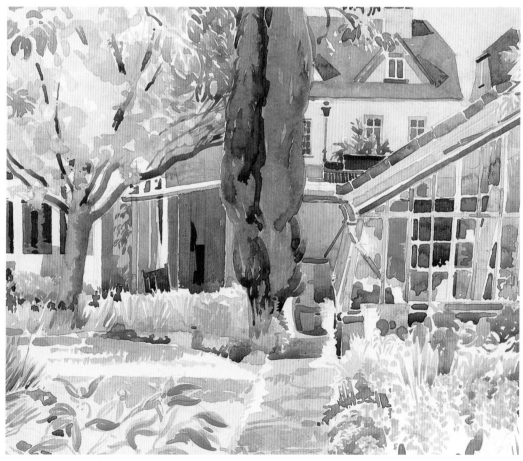

The garden in May. Watercolour, 51 x 66cm (20 x 26in)

Chapter Three
COLOUR

When choosing a palette for the first time, you do need to obtain certain basic pigments. Some student's quality tube sets may be useful as you get the feel of the medium, but I would not recommend pans of these colours. Artist's quality watercolours are better in the long run; the pans are moist, the colour range greater, and the quality finer.

An essential palette consists of two of each primary colour – a warm and a cold of each. I would then add a couple of useful earth colours, burnt sienna and yellow ochre. The secondary colours viridian, cadmium orange and violet, are the most useful additions to a predominantly light palette.

You will find a few other colours in my chart below. Light red and raw sienna are comparable to burnt sienna and yellow ochre. I also find raw umber to be useful on occasions. I would very seldom find a use for any

Primaries

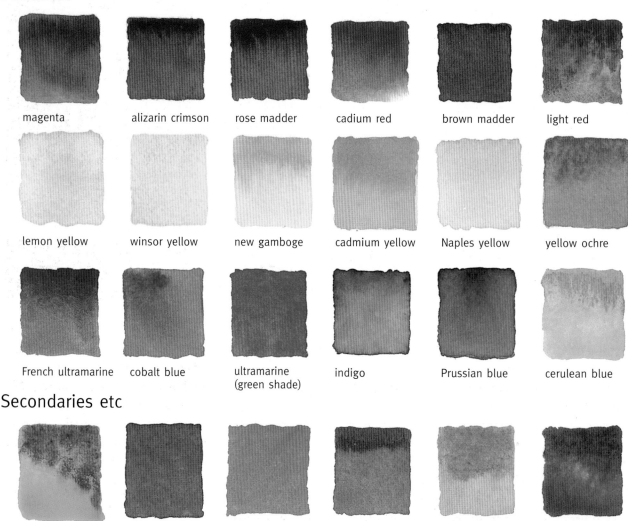

magenta	alizarin crimson	rose madder	cadium red	brown madder	light red
lemon yellow	winsor yellow	new gamboge	cadmium yellow	Naples yellow	yellow ochre
French ultramarine	cobalt blue	ultramarine (green shade)	indigo	Prussian blue	cerulean blue

Secondaries etc

viridian	winsor violet	cadmium orange	burnt sienna	raw sienna	raw umber

other browns, greys or blacks, as they tend to make the work dull.

A selection of new and modified pigments has recently become available. It is always valid to take note of such developments; my latest acquisition is the ultramarine (green shade), which is not yet widely used. However remember that the great artists have often managed very well with a modest range of colours on their palette.

COMPLEMENTARY MIXES

The chart on the right shows six examples of colour-mixing with pigments that are, in each case, complementary pairings. They are not true complementaries in the scientific sense. If they were, the resultant mixes would include a perfectly neutral grey. The red/green combinations come closest. In the blue/orange example, both contain too much yellow. A cobalt blue, in place of the cerulean, with an orange containing more red, would give a more neutral product. These, and other pairings, are very useful in the early stages of paintings, as can be seen overleaf.

Complementary duets offer several advantages:

- Each consists of a warm and a cold colour, which in some cases leads naturally into a separation of light and shade.
- They enhance each other when placed together, as at the top of the chart.
- They produce a set of harmonious neutrals.
- They either include a strong-toned pigment or combine to make one.

Complementary colour mixes

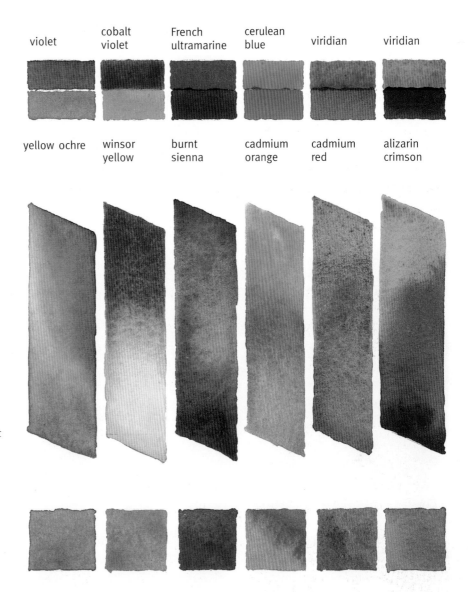

violet cobalt violet French ultramarine cerulean blue viridian viridian

yellow ochre winsor yellow burnt sienna cadmium orange cadmium red alizarin crimson

- Between them, they contain most of the colours of the spectrum (ideally, all of them).

It would be a very useful exercise to produce a similar chart of your own. Use what appear to be similar pairs of colours from your set. The long continuum, showing a gradation between the colours, is best achieved by wetting the shape first and introducing the colours at each end. Make some mixes in the palette as well, in order to gain knowledge of the capacity of your chosen pigments to make neutrals. You will find these are potentially much more colourful and harmonious than ready-made greys.

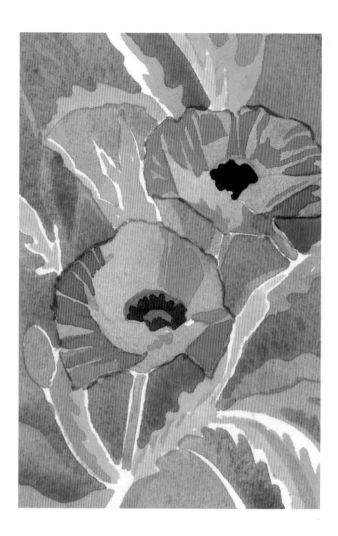

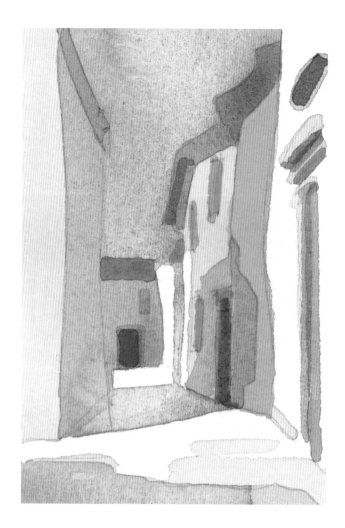

COMPLEMENTARY SCHEMES

The sketches above and right are suggestions for colour schemes, based on the qualities and potential of the complementary colours detailed on page 27. They show some simple and constructive ways of getting straight to the heart of a colour composition, using two pigments. The striking aspect of this, is the range of colour and tone variation to be obtained by this simple means, with the white of the paper playing a part.

Try painting a similar set of sketches based on your own drawings and ideas. See how far you can take

the work without resorting to a third pigment. This exercise will help you to learn more about how the colours in your box work. When you do bring in additional colours, it will probably be:

■ To extend the colour range, e.g. adding bright yellow to an ochre.

■ To extend the tonal range, e.g. adding a deeper red to a cadmium.

■ To achieve a more descriptive effect of the observed colour.

■ To follow your instinctive desire for more active colour contrast.

When working from observation, you need to develop the ability to see beneath any notes of dramatic colour. Often these highlights will be the very thing that drew you to the subject. It is advantageous, however, to find an underlying colour and tone structure which might be established with a pair of colours. Highlights and top colours will then have a context and carry greater potency. This is always partly subjective, but referring to your complementary chart may help you to relate your palette of colours to your observation.

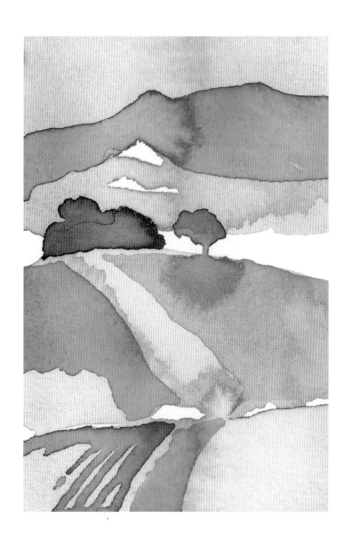

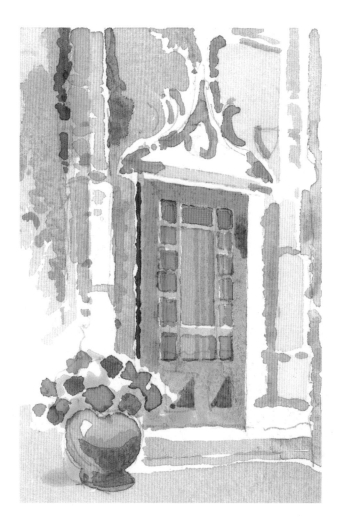

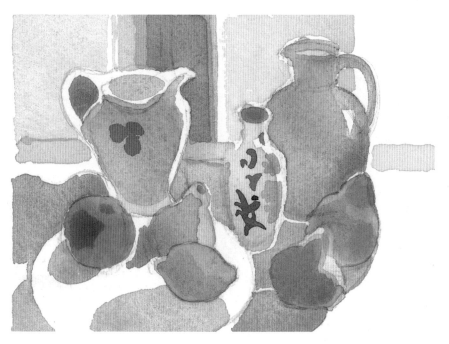

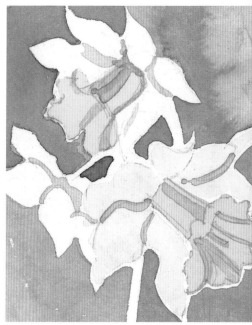

COLOUR AND LIGHT

Light is made of colour. This scientific fact is significant for artists who also recognize the difference between the light spectrum and the range of pigments. The colours of the spectrum combine to make white light, but the pigmentary colours add up to black. It is possible to exploit the light which shines through transparent watercolour, so we do need to value the light source. The painting *A setting for amaryllis* is a work in which I have built on this premise. The white paper is very much the catalyst. The first brushmarks and lines were made with yellows – Naples, lemon and cadmium. The cooler colours, still light in tone, were added next. The passages of deeper-toned blues and greens followed, and the light violets and stains of crimson and magenta came last. The foliage area at the heart of the painting has been enriched with cerulean blue. For these passages the work was laid flat and the colour allowed to stand in small, very wet islands to dry naturally.

Light can, of course, also be evoked by contrast with dark, but there is a tendency to miss out on the contribution that colour can make to the darks. This happens frequently when working from photographs. The problem with photographic reference is that the shadows are often too black and skies are featureless. Good painting from such sources can come only from a selective use of the information in the picture alongside reference to notes and sketches made to complement the photograph.

A setting for amaryllis. Watercolour, 51 x 51cm (20 x 20in)

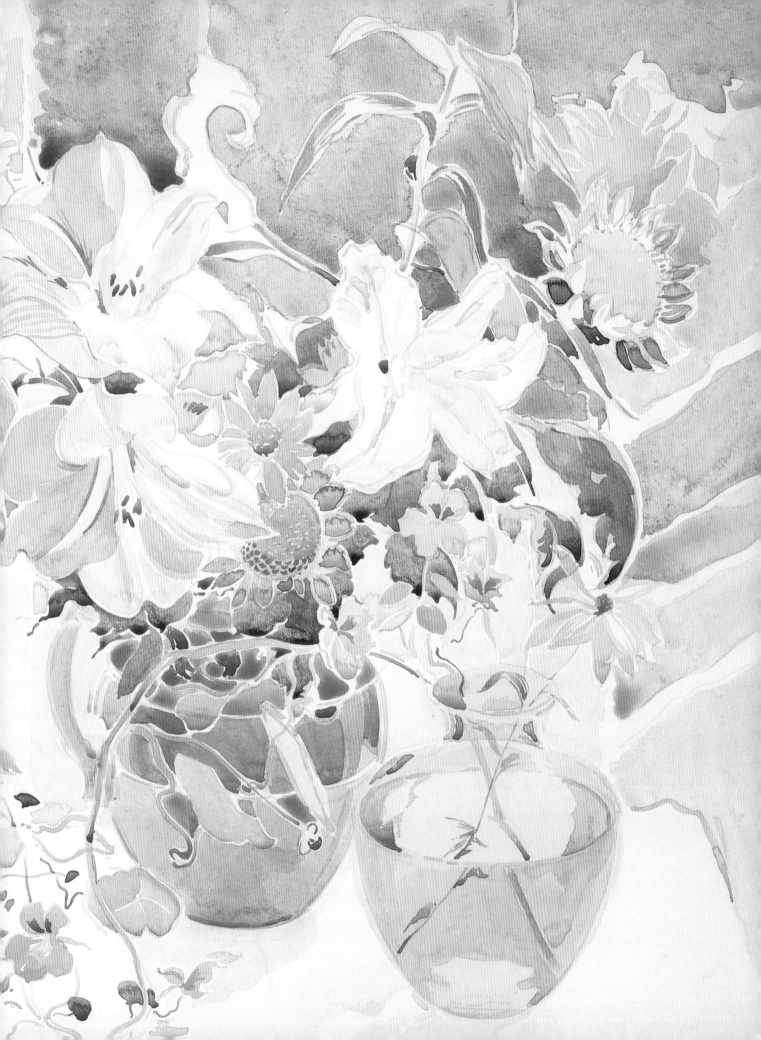

COLOUR AS TONE

The still life sketch below is an example of pigments used at full strength to depict local colour. Watercolour is not the immediate choice or the best medium for this type of subject; oils, acrylics or gouache give more density. I include it here because it is useful to recognize that there are situations where a watercolour pigment, used at almost the maximum intensity, can result in work of great range and richness, with the colours remaining transparent. You will notice that there are some reflections between the objects and that the watery start has given some softness which contrasts with the harder shapes.

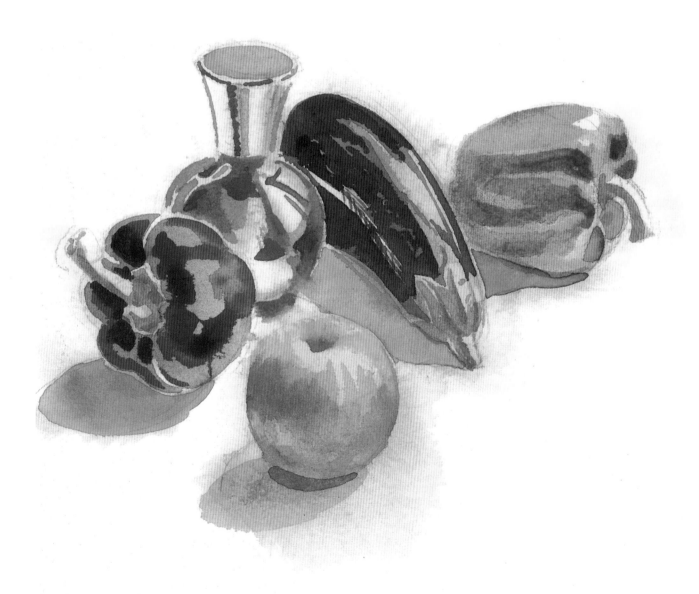

Fruit (colour as tone). Watercolour, actual size

COLOUR FOR RECESSION

The illustration on the right shows ways of setting up an illusion of depth. The depth is aided by bands of landscape which alternate in tone while becoming progressively lighter. The intervals also vary in dimension but, again, tend to diminish in the distance. Similar principles can be applied to other imagery, even within the shallow space of a still life. Every time we set one element in front of another, we can employ tone, colour temperature, scale and linear perspective to help create the illusion.

Opinions differ as to the capacity of warm and cold colours to advance and recede, but we can all observe that the atmosphere makes distant colours appear cooler. It is evident therefore that nearer elements are seen to be warmer by contrast.

In any case, it is the management of tone values that takes precedence. This should be kept in mind, especially when you are aiming to give dramatic effects through colour. The making of monochrome studies is a useful discipline, to intersperse with more colourful sketches.

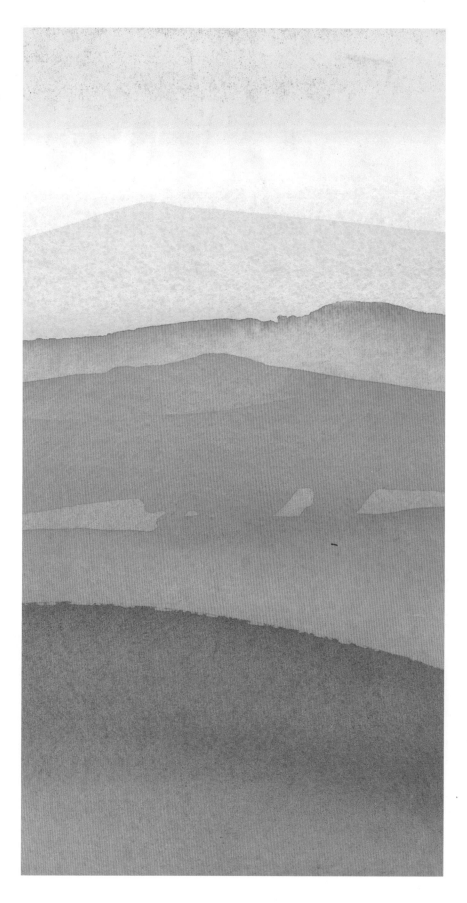

Landscape (colour perspective).
Actual size

Chapter Four
DRAWING

This illustration is not intended to reinforce the notion that drawing is just about pencils. The following pages will illustrate the varied drawing techniques available. It may seem trite to repeat the adage that drawing is seeing, but it is true. The eye is trained to encompass the whole of a scene, not just the detail, but, more crucially, to gain awareness of relationships and proportion. Drawing is also the most direct form of visual communication. It is the way we work out ideas, as well as being the best way for an artist to gather information. When you make a drawing, you naturally select and emphasize, and you have immediately begun the journey towards picture-making.

Drawing is not just a matter of lines, and to limit your drawing to the underpinning of watercolours is to miss out on a great deal. You need to value the flexibility and range of the technique.

I believe that the most interesting watercolour painters are those who work in other media as well and who prioritise observation and drawing. In the following pages of this chapter I have illustrated just some of the aspects of drawing for your consideration.

A drawing for a watercolour painting will vary according to the painting's purpose. It may need to be quite elaborate for complex subjects, or it could be very sparse serving as a guide for brushmarks. In either case, it is advisable to avoid indenting the paper with hard marks. A soft pencil is most appropriate and it is better to avoid using an eraser, as this can spoil the paper surface. Alternatively, you could start with a pen.

Remember that the sketchbook is essential for artists wishing to cultivate the habit of drawing. Most of my drawings are done in books of cartridge or pastel paper. In each case I look for a weight and quality that permits the occasional wash of paint when required.

Watercolour sketchbooks are useful for painting on location, but I do not find the grainy textures conducive to good observational drawing with pencil or pen, when a quicker linear flow, or a finer detail is needed. A book that fits into your pocket is useful for all kinds of notes and drawings, and a larger book can be used for the times when you want to plan a working session.

Blaston. Pencil, 28 x 38cm (11 x 15in)

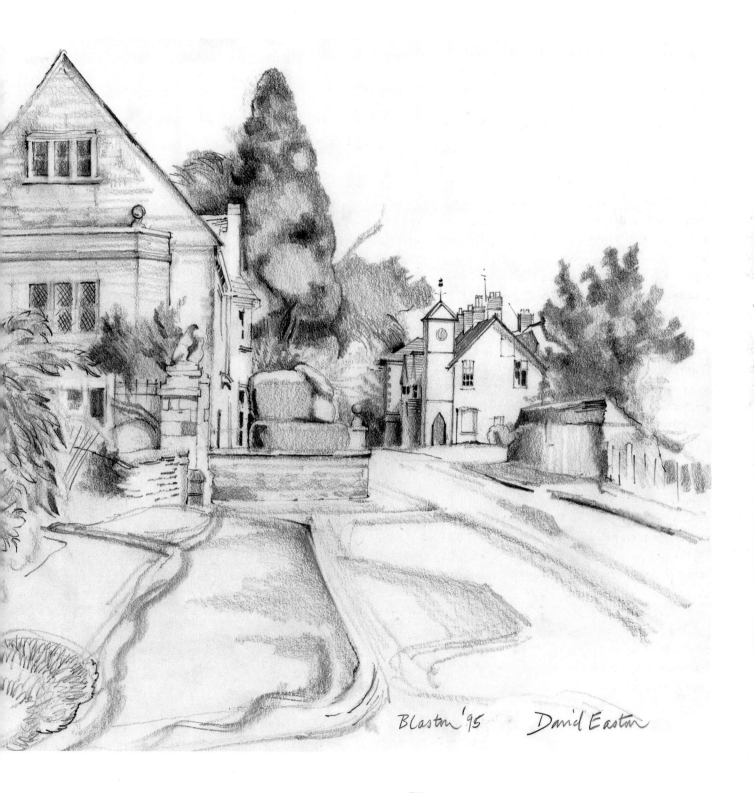

Blaston '95 David Easton

MOVEMENT IN DRAWING

This study of irises drawn at stages of their opening shows how these flowers take on many different shapes as they emerge. You can learn more about the forms by observing them and then incorporating this variety into paintings. Movement can also be created through the drawing itself, where there is an energy flowing through the work which guides the observer's eye.

The drawing on the opposite page has this effect, with the many linear directions emphasized with a pen line. It is a mixed-media drawing made in a botanic garden. I set out to make a painting on the spot, but having sketched in a few pen lines, I realized that I was using unfixed ink. The best option then was to make colour notes with crayons. This was done on handmade Arches watercolour paper, a surface which gave a pleasing softness to the colours. This turned out to be a useful reference for a watercolour painting.

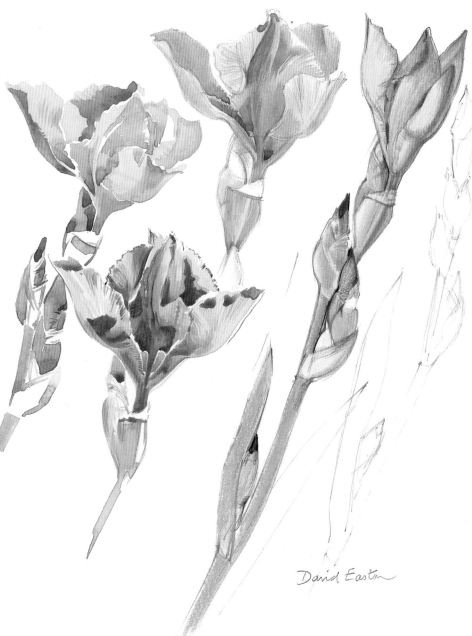

Yellow irises. Pencil and watercolour,
33 x 25cm (13 x 10in)

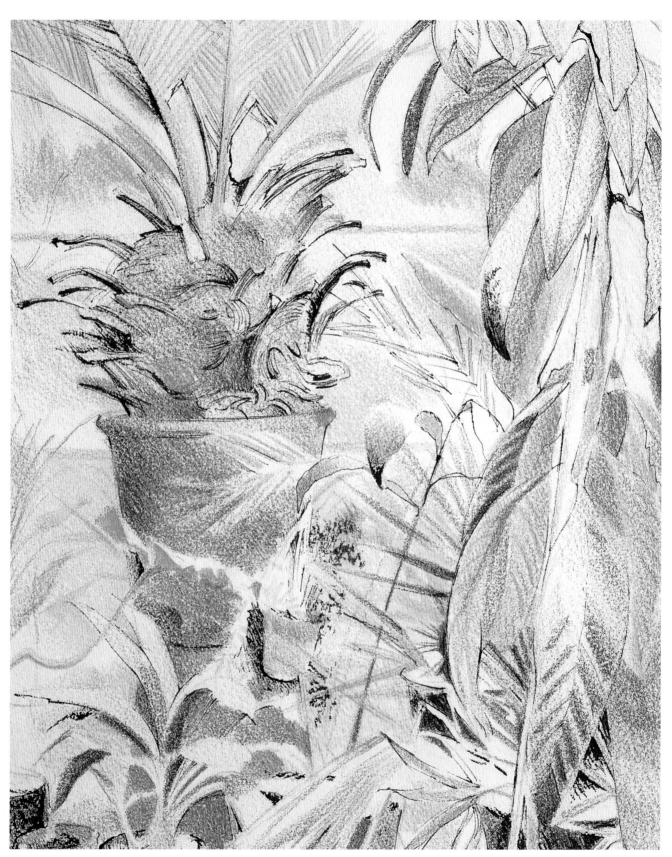

Botanic greenhouse. Pen and crayon, 33 x 20cm (13 x 8in)

DRAWING FOR PAINTING

There are many ways of assembling while researching a painting. These three studies give an idea of some alternatives, each related to tulip paintings. The pencil drawing is a meticulous illustration seeking to clarify the forms, perhaps with a view to making a painting composed of several separate elements, such as the lily paintings on pages 63 and 65.

The other two studies have a different nature and purpose. The crayon drawing shown opposite could have a similar application but this type of study is more open-ended and I could envisage a number of opportunities where it could provide a passage in a painting. It is an advantage to have an analytical drawing, even if it is to be interpreted in a free painting which still needs an underlying accuracy of structure.

The watercolour sketch is a quick study for a composition. The objective in the sketch was to achieve a sense of the colour and tone balance. It is the type of study that might precede a larger painting in front of the actual subject.

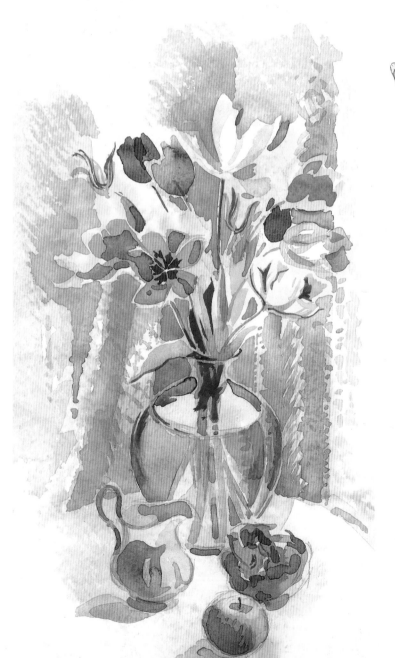

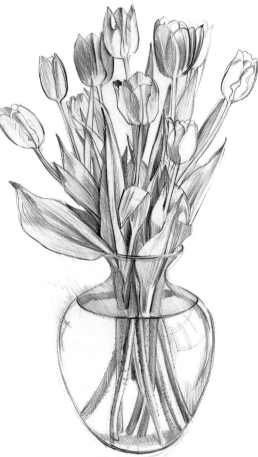

Tulips. Pencil, 33 x 20cm (13 x 8in)

(Left) *Sketch for tulip still life.* Watercolour, 25 x 13cm (10 x 5in)

(Opposite) *Tulips.* Crayon, 33 x 20cm (13 x 8in)

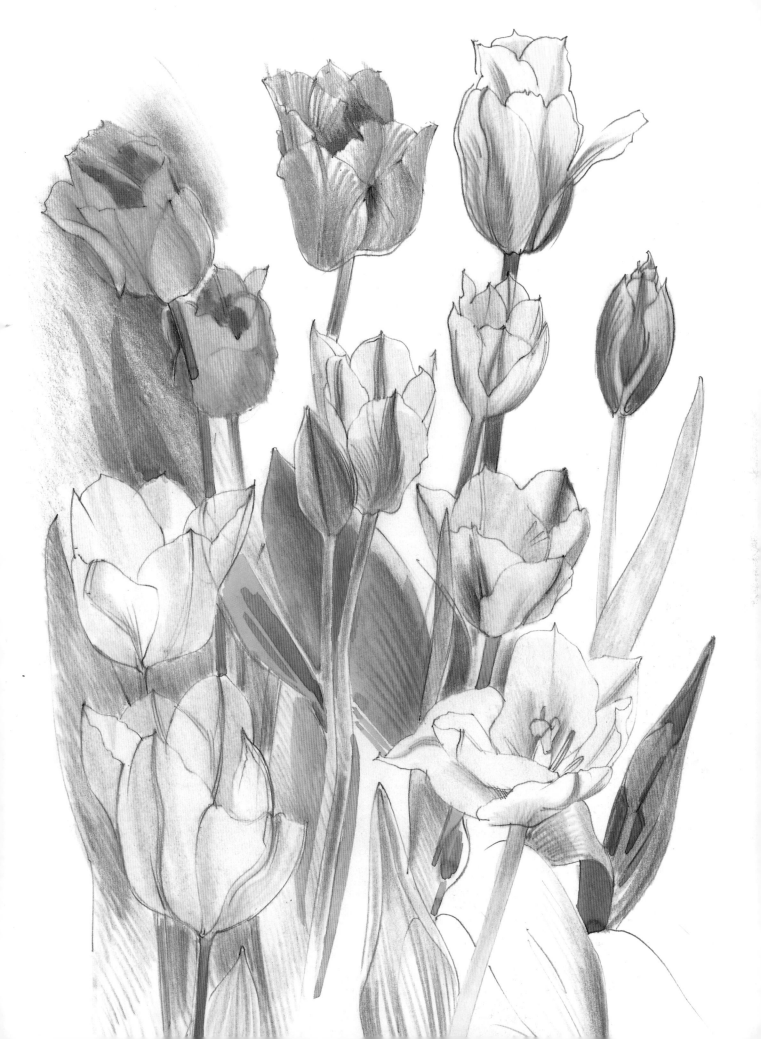

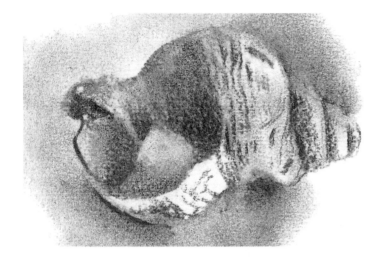

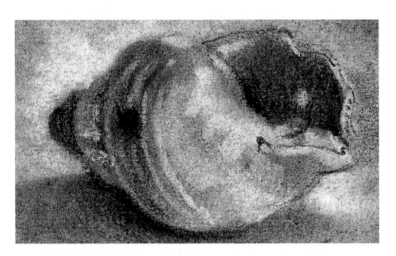

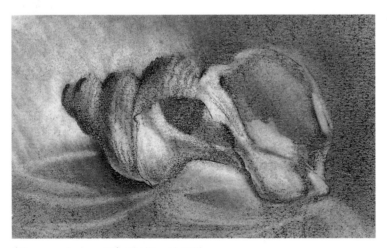

(Above and opposite) *Shells* and *Still life*. Tonal drawings, actual size

TONAL DRAWING

These graphite and charcoal drawings contain very few lines. In the case of the three shell drawings, the method precluded the use of line. The top study began with the preparation of an area of graphite, which was firstly shaded on to the paper with soft pencils. A soft, clean rag was then used to rub the pencil lead into the paper, giving a more or less even tone. The light parts of the shell were then lifted out with an eraser. The process continued with soft pencil drawing and more erasing.

The second drawing was done in precisely the same way, but using charcoal, which is easier and quicker. I used reusable adhesive putty as an eraser this time, but a soft putty rubber would do the job equally well. The third drawing is made with charcoal and the tones are obtained by rubbing on the paper with the finger. Each method produces a drawing without line. Try this yourself, starting with a single object and this will help your understanding of tonal values.

The still life study on the opposite page was made while exploring the idea for the painting on page 58. The painting did not take on all the tonal attributes of the drawing. You will notice that this pencil drawing has a selective emphasis, with sharp accents focusing attention here and there. None of the objects is given a completely solid outline. The lines become more and then less defined in response to the way we actually see, rather than to what we know about the forms.

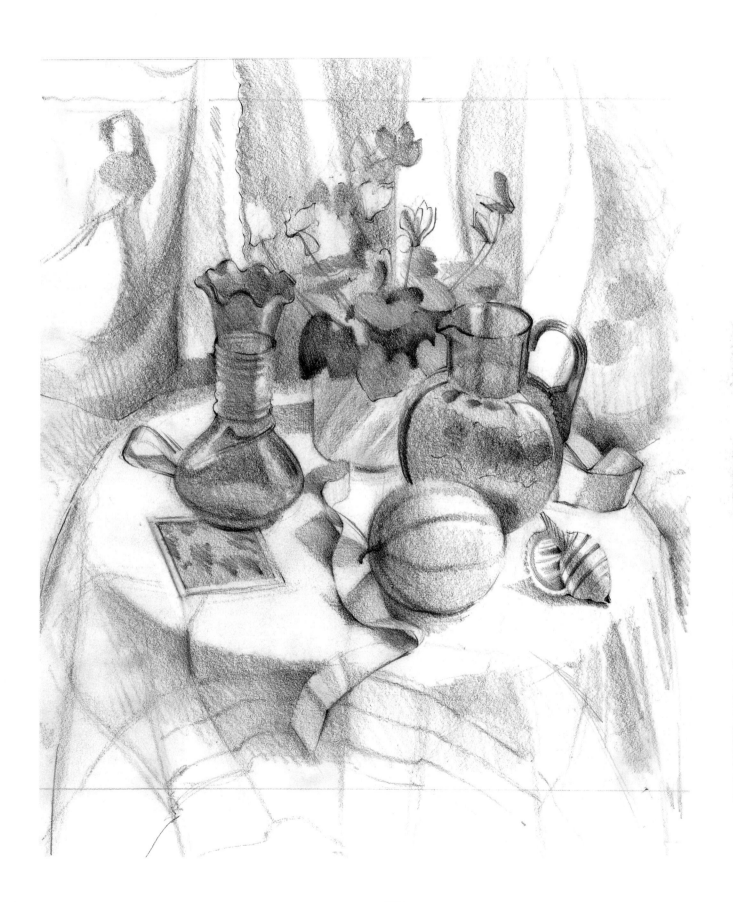

PEN DRAWING

From time to time I like to focus on line drawing in my teaching to show that line is worthy of individual study. The use of pens encourages a flowing drawing technique resulting from the tension balance between the point of the pen and the surface of the paper. While I was studying, the use of the fountain pen was encouraged. As ink drawings are indelible, you can only change your drawing by adding marks. This is a rigorous training for for the accuracy of your observation.

The drawing of the cyclamen plants seen here was made with a dipping pen, a flexible metal nib and a grey unfixed ink. It is composed entirely of lines, some of which are hatched to indicate tone. The ink has been watered down in places to give a little variety.

The hydrangea plant shown on the opposite page is drawn with an Artpen, a fountain type which takes cartridges of ink. Coloured inks and several nib widths are available. I have used some clean water to take washes from the unfixed ink. With practice it is possible to retain the pen line while using the wash in the areas of shadow.

The sketch of boats is an example of a useful technique which enables you to obtain information quickly. This sketch was drawn in a pastel book with a pen and then given a little colour and heightening with crayons. Oil pastels are also very useful over pen on toned surfaces.

Cyclamen. Pen and grey ink, 36 x 28cm (14 x 11in)

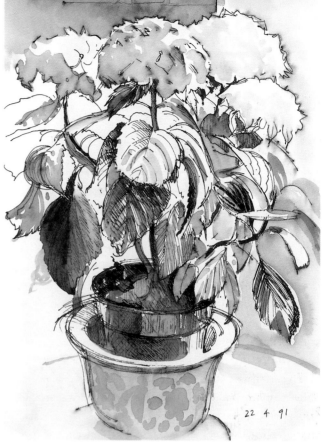

Hydrangea. Artpen and wash,
23 x 15cm (9 x 6in)

Boats at Sausset. Artpen and crayon on
grey pastel paper, 15 x 23cm (6 x 9in)

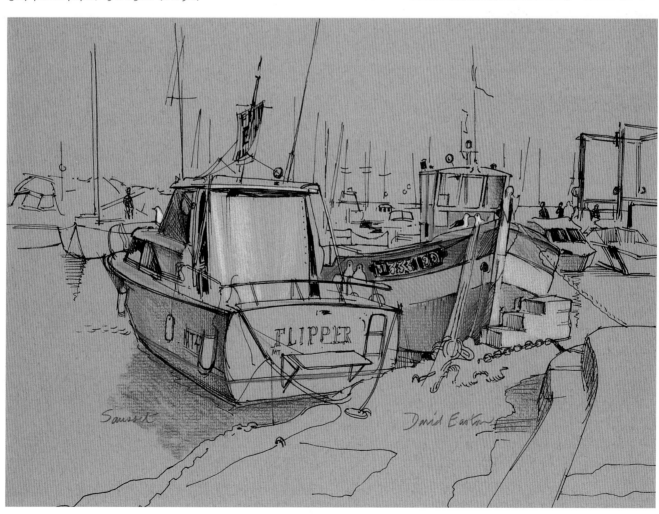

Chapter Five
STILL LIFE TECHNIQUES

Still life was out of favour with artists and their clients for many decades, until the late 19th century. Paul Cézanne helped to raise its status with his many works in this genre, including watercolours. These have been a major influence on 20th century artists, from Matisse, Braque and Picasso to the present day. For the contemporary artist, the study of still life offers a combination of discipline, variety and challenge. The next few pages cover the setting-up of a group, making a start with painting, and looking at viewpoints.

Techniques range from the traditional wet-over-dry, as exemplified by the painting on the right, through various degrees of wet-in-wet, to the use of opaque pigments.

The great advantage of this subject matter, from the close-up of a few small objects to the furnished interior, is the degree of control that is possible for the artist. Settings can be arranged and lit as required, the studio equipment can be close at hand and there is a level of privacy and comfort not usually found on location. All these factors suggest that the desirable practice in skills, and the devlopment of visual judgement, can take place through the study of still life.

The painting shown opposite, *Still life with lamp*, is a watercolour which was carefully prepared over several days. During this time a number of related sketches were done, including the pen drawing of the plant on page 43 and *White hydrangea* on page 104.

The group contains many features which inspire interest: plant, glass and ceramic objects, printed matter, fabrics and decorated surfaces, and the sense of light, often directed from behind. The usual formal elements of colour, tone, texture and line are present. The light brings the colour to life and this is a challenge for the artist to interpret visually. I enjoyed painting alternate sets of warm and cold shapes for the tablecloth. The plant, not the main focus in this work, is painted in the selective way that characterizes the *White hydrangeas* (see page 104), with the foliage rendered in the part wet-in-wet technique shown in the cyclamen detail on page 16.

Still life with lamp. Watercolour, 66 x 51cm (26 x 20in)

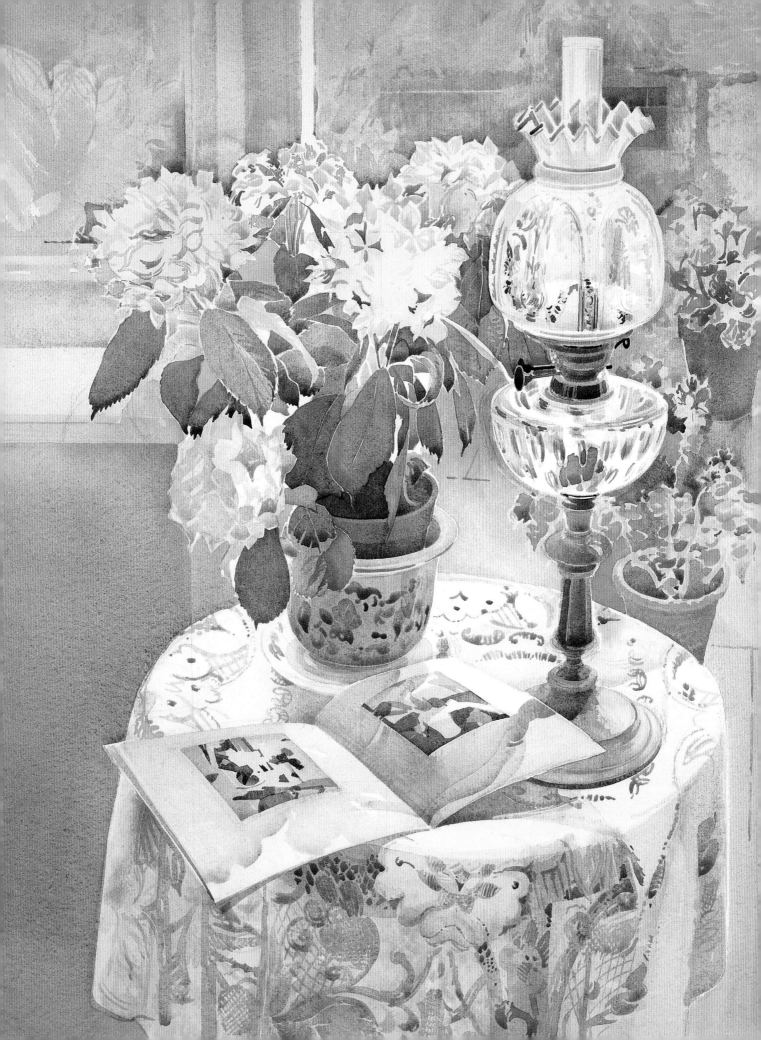

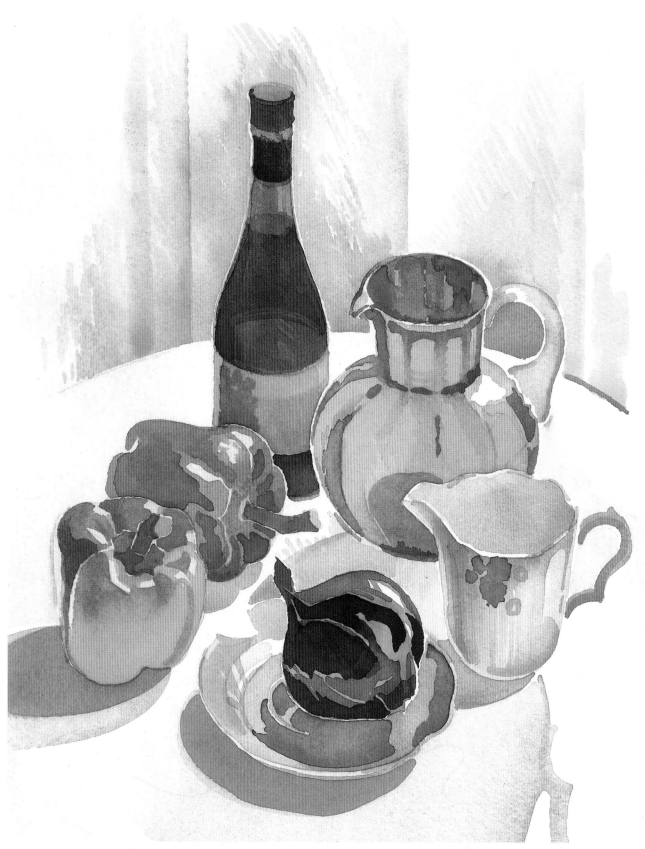

(Above and right) *Still life.* Pencil and watercolour, actual size

SETTING UP A STILL LIFE

The two small sketches on the right show a simple still life with both man-made and natural objects. They have been chosen to give a range of colour and form. The problem that beginners faced with such a diversity of colour must overcome, is how to identify common factors for the first part of the painting process. The pencil sketch below is useful in that it identifies the distribution of light and shade. The watercolour sketch above gives an idea of how one colour can be widely used throughout a painting. In this case the blues were applied in several washes, each being allowed to dry before the next was added.

A similar start was made in the larger illustration shown left and the local colour of the objects was then glazed over very fluidly. This mostly involved reds and yellows, which were affected by the underlying blues to give the secondary and tertiary colours. This is a very controlled way of working and resembles the process of printing colours. It is a useful way of assessing the effect of visually mixing one colour with another.

Try other combinations of your own. You will probably achieve more satisfying results from cold colours overpainted with warm, because the early part of the task is about separating light and shade. Suitable shadow colours include violets, blue/greens and greys (mixed perhaps with complementaries) or any combination of these. Start simply, and then be more adventurous. It might also be advisable to choose an even simpler group of objects, but do set the group in a good side light.

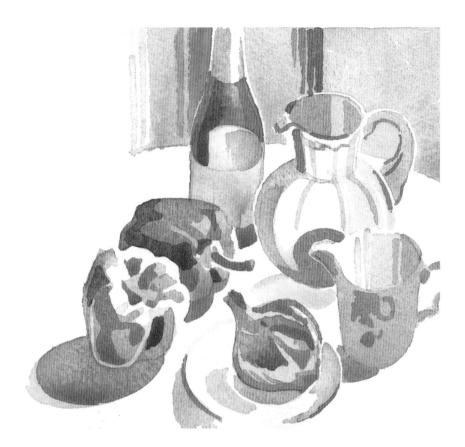

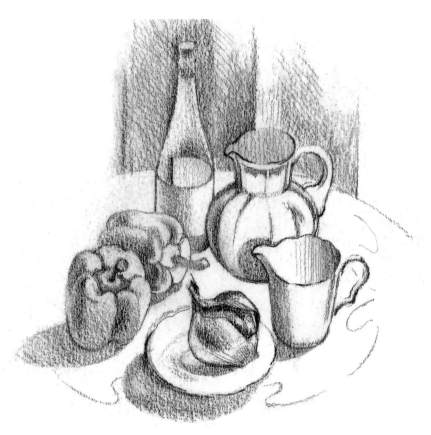

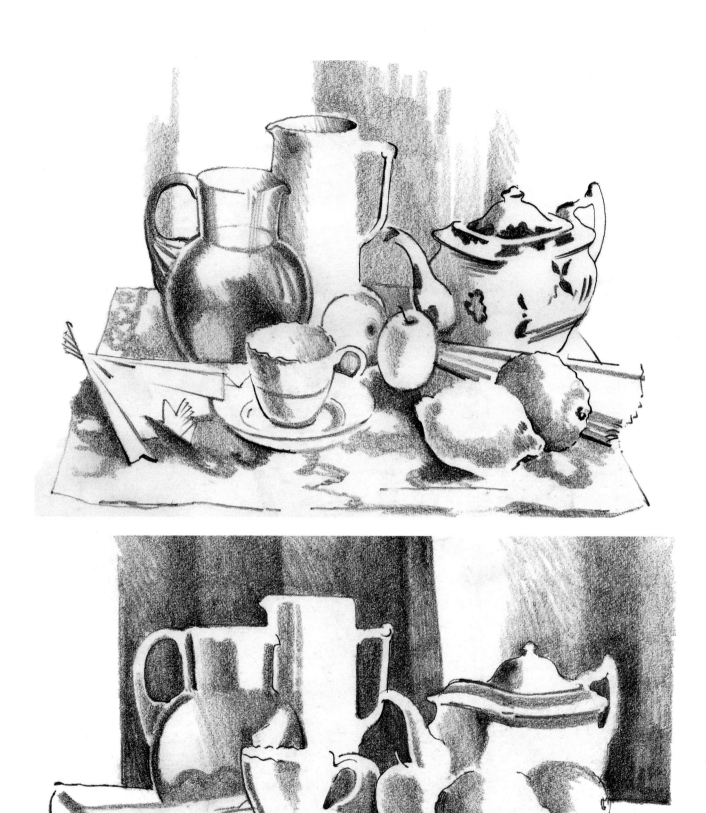

Still life (setting up a group). Pencil, actual size

VIEWPOINTS

After looking at simple beginnings, we will try something more elaborate. The sketches on these pages are all from the same group of objects, but seen from different viewpoints. The first consideration is to set up the still life to allow you to move around the group, or to move the group itself. A drawing board, tray, sturdy box or light table can serve as a base.

I have had the interesting task of creating a group for three or four students to work from together. The sense of the group being 'in the round', like a sculpture, is helpful and makes you more aware of the spaces in between and the overlapping of shapes integral to still life study.

The first drawing is from a conventional viewpoint. We are looking down on to the group, which is just below our eye-level. The ground-line and the skyline are quite varied.

The second illustration shows the group viewed nearer eye-level. You can see that now there is a very flat ground-line and flat ellipses to the pots, but the skyline is potentially more dramatic and background tones can heighten this.

The third viewpoint is from well above and from a different angle. The objects, still in the same positions, have been lowered to the floor. Ellipses are open and the surface on which the objects are standing becomes central to the composition.

All these options, and many more, are open to the still life painter. If you are lacking inspiration using a conventional viewpoint, try some of the more unusual angles.

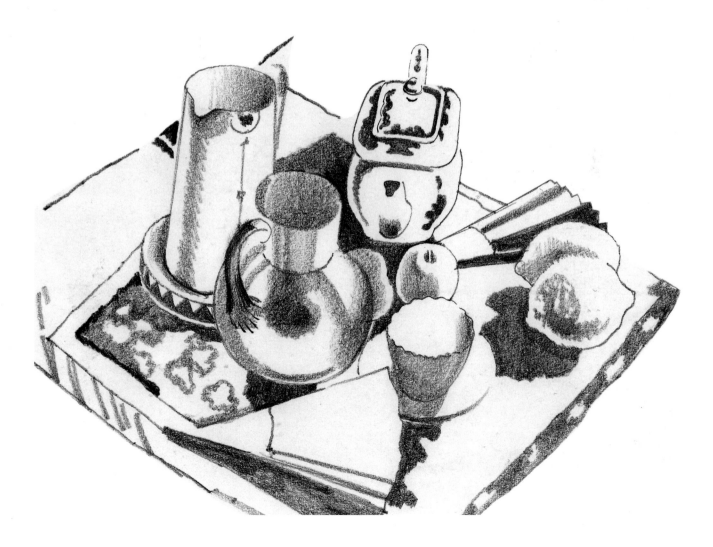

COMPOSING WITH
A VIEWFINDER

With the invaluable aid of a simple viewfinder (a rectangular frame made from cardboard), I have looked at the same group of objects, from the same viewpoint, and isolated two potential compositions. You can find a different option within the group simply by holding the cardboard frame further away from the eye. The sketches are shown at the actual size.

I used samples of Fabriano papers for the sketches. These were taped to a board with masking tape, which was adequate for the small 300 and 600gsm samples. This enabled me to wash the areas with clean water to start a wet-in-wet technique. I adopted this method to encourage freer sketches, to allow me to concentrate on the colour composition and to avoid detailed drawing. Both pieces were painted on the same board, in order to work on one as the other dried, before adding the clearer wet-over-dry shapes.

Investigate this idea yourself by taping up to four small off-cuts onto a board. You will find that the change of pace is refreshing. It is a good way of taking a new approach with colour, but keep an eye on the tonal values which are vital to the effectiveness of the design.

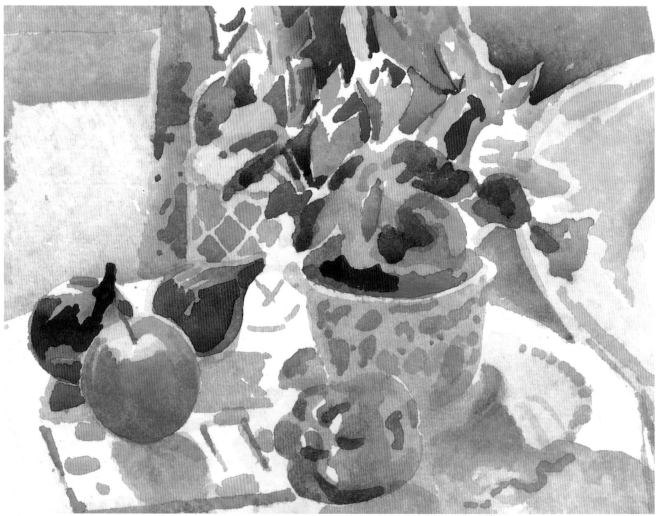

Still life composition. Actual size

Similar strategies can of course be employed for any type of subject. This approach offers a very useful way of sorting out some of the picture-making ideas at the outset, before embarking on a larger or a more descriptive painting.

You can identify the main elements of your composition, and decide upon the pigments to use in framing your colour scheme. Above all you are able to get to the heart of what really interests you about the motif.

This essential image can so easily become lost while working through a longer period. The initial sketch, with its immediacy, can serve as a reminder of what you are aiming to achieve.

Still life composition. Actual size

Chapter Six
STILL LIFE INSPIRATIONS

FANS AND VASES

The linking theme in this series of still life groups is the use of fans and oriental vases in the setting. I have found that books, cards and other items of printed matter are useful in providing straight edges and directional elements, helping to describe the ground plane and marking out spaces between objects. Fans can also be used for their flat colour or their decoration. My still life work is inspired by contrast between curves and straight edges, volume and flatness, texture, pattern or plain. These contrasts are invigorated by the interaction of warm and cold colour contrasts, and the achievement of harmony and balance.

In *Still life with tulips*, interplay occurs between the layers of closely related colour which are laid in directional strokes. The foliage has this characteristic, as do the fan, pineapple, the edges of the fabric, and the lip of the large jug. The fan is placed to balance the pineapple. The predominantly warm colours are relieved by the blue passages, with the fan and the background fabric supporting the vase. Above all, I enjoyed the energy which the moving rhythms in the composition provided. The detail seen left shows how the objects have been put in as simple shapes, with stronger tones laid over to give a degree of form. It also shows how the cool theme pervades in the shadows. It is generally better to apply the decoration on surfaces such as the vase after giving the object its tonal washes. The principle is to work from broad forms to finer detail.

Still life with tulips. Watercolour,
76 x 54cm (30 x 21in)

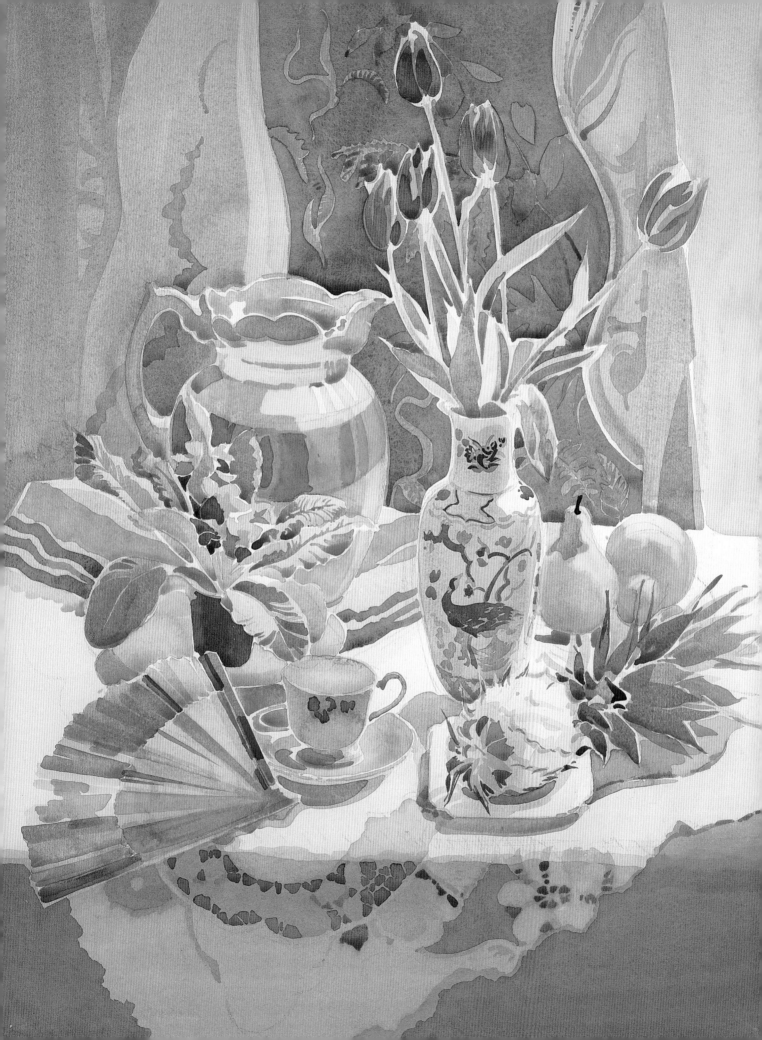

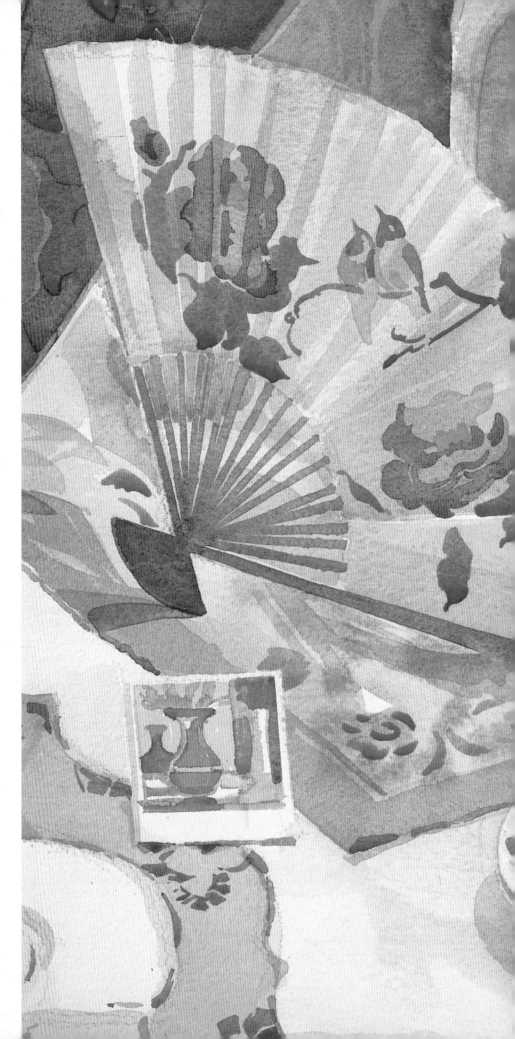

Still life with fans uses some similar elements, but it contains more decorated surfaces. I became interested in the way the flowers on the painted fan relate to the actual flowering plant. One of the contributions that the large fan makes is to slice across the vase, preventing the shape repeating that of the small vase.

The achievement of a satisfying colour composition is crucial with still life paintings, especially those with a floral subject. This begins with the arrangement of the group to give colour interest throughout. The colours are painted as they appear, but the painting should take on its own direction at some point, which may involve the addition of new colours or objects. This is never predictable, which makes it often frustrating yet also exciting.

Still life with fans. Watercolour, 51 x 66cm (20 x 26in)

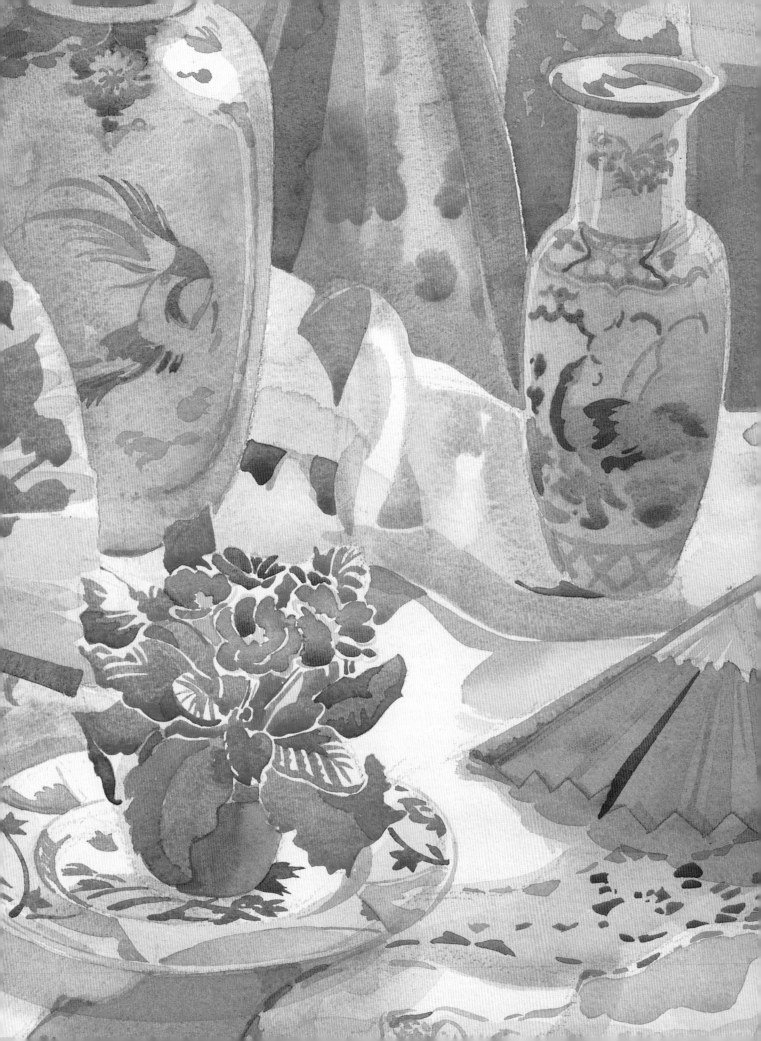

The group used for *Fans* was set up on the floor and the viewpoint can be identified in the perspective of the vase. The group took a long time to arrange; a measured drawing was squared up and traced lightly on to the paper before I began painting in front of the motif. I would only resort to preparation of this sort when tackling a complex subject with such exacting forms. The distribution of white, appearing in varied shapes, forms the main composition and most of the more saturated colour is contained at the heart of the work.

There are many passages in this painting where decoration is applied to forms which are turning or folding. The planes are convex and concave, and are presenting surfaces in varied light situations. These structures need to be established before the decoration is applied. Careful assessment of the colour and tone intensity is necessary throughout, so that nothing is out of key with the overall design.

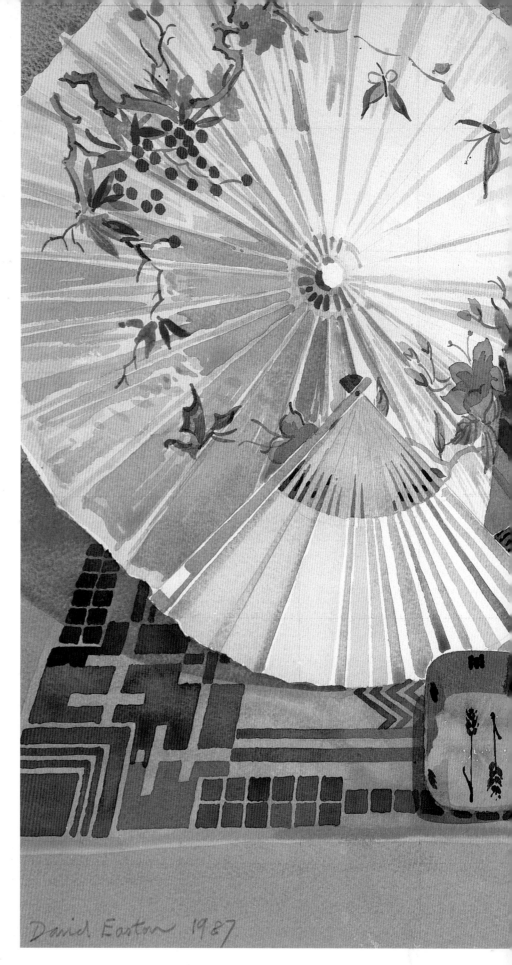

Fans. Watercolour, 54 x 66cm (21 x 26in)

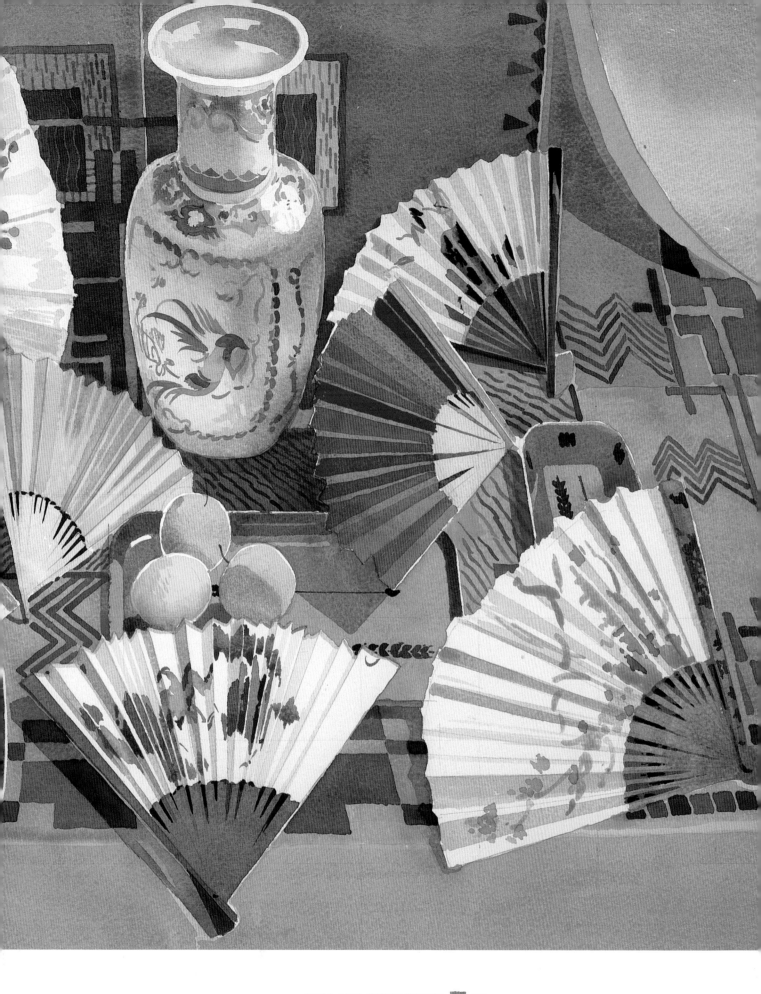

Still life with coloured glass is one of a series of small square paintings, many of which feature groups of objects set on a round table against a background of drapes. You will find a drawing on page 41 which I made at the same time. Some of the tonal features of the drawing are evident, but I became more involved with the colour, the facets and the curved stripes and segments which characterise the work. Some direct drawing with a pen and acrylic ink led the way. A ribbon enabled me to break some light down the picture plane and gave poise to the group. Acrylic ink again provided some locating marks for *Still life with banded pot* and a wash of the same medium augmented the watercolour to give a resonance to the deep orange-coloured squash, set among complementary greens to give a colour focus. There is very little table surface in this painting, but it is implied by the saucer, the relative placing of the objects, an odd shadow, and the arc of the table itself at the bottom right. Another aspect that I find pleasing is the steep diagonal emphasis that characterizes the left two-thirds of the composition and which is set up by a series of parallel strokes in fabric patterns and folds and by the axis of the squash. This directional pull is held in balance by the countering direction of the marrow and by the vertical axes of the man-made objects.

Blue and ochre still life is another small square painting from the series with a simple colour scheme. In this painting, the freely drawn leaf shapes in the background are echoed in the sprig of ivy which crosses the table, in a direction that counters the flow

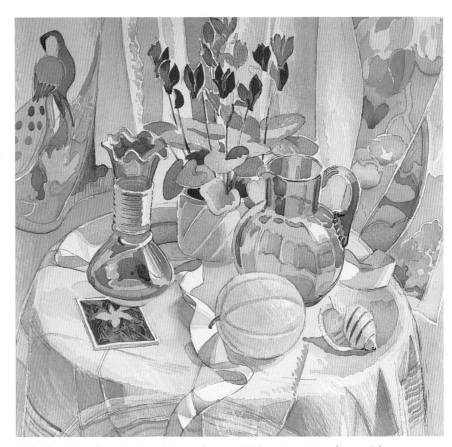

Still life with coloured glass. Watercolour and inks, 28 x 28cm (11 x 11in)

down from right to left. This diagonal connects the two darker focal areas. Notice the blue acrylic ink hatchings and the linear brush-drawing that make this an open and light piece, with just a few solid areas of colour to give shape and stability.

In the full-sheet painting *Still life with peacocks*, shown on the next two pages, I was able to pick up on the colour scheme of the previous work. The autumn sunlight prompted me to use more yellows, with blues to separate the shadows. Burnt sienna followed to extend the range of warm colour and to turn some blues into greys. The white paper is always in evidence, keeping a sense of light throughout. You will notice that none of the yellow pigments are very sharp

but, where they are richer, they help to create a sub-grouping within the composition. I enjoy the way that the bird images relate to the jug handle and the glass vase. The choice of a motif like this and the process of setting it up emulate Paul Cézanne's still lifes. His groupings of fruit continue to inspire me.

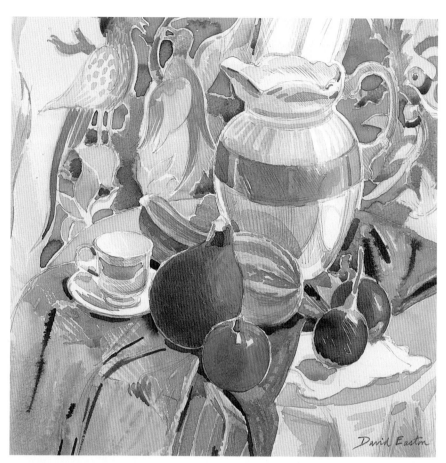

Still life with banded pot. Watercolour and inks, 28 x 28cm (11 x 11in)

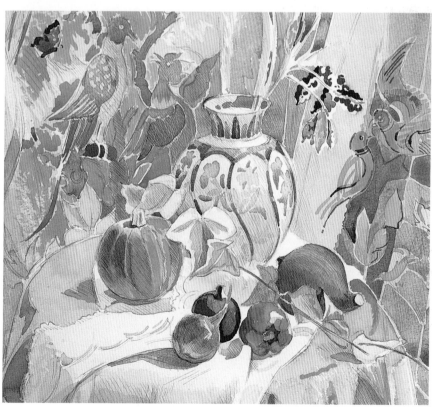

Blue and ochre still life. Watercolour and inks, 28 x 28cm (11 x 11in)

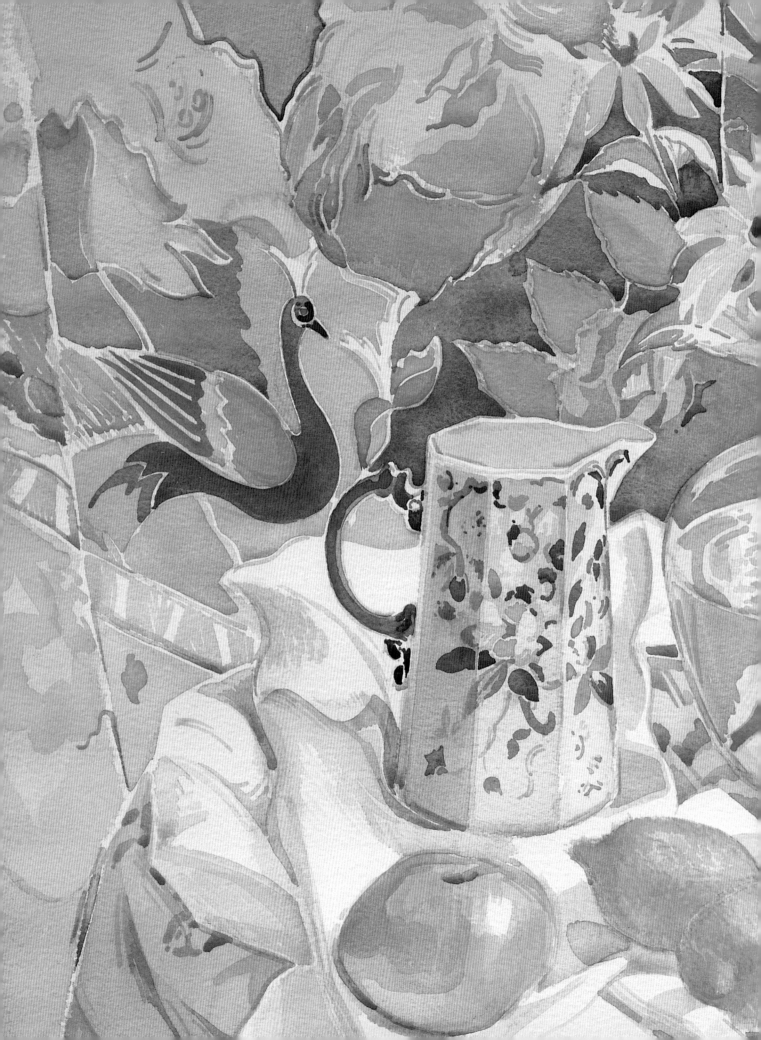

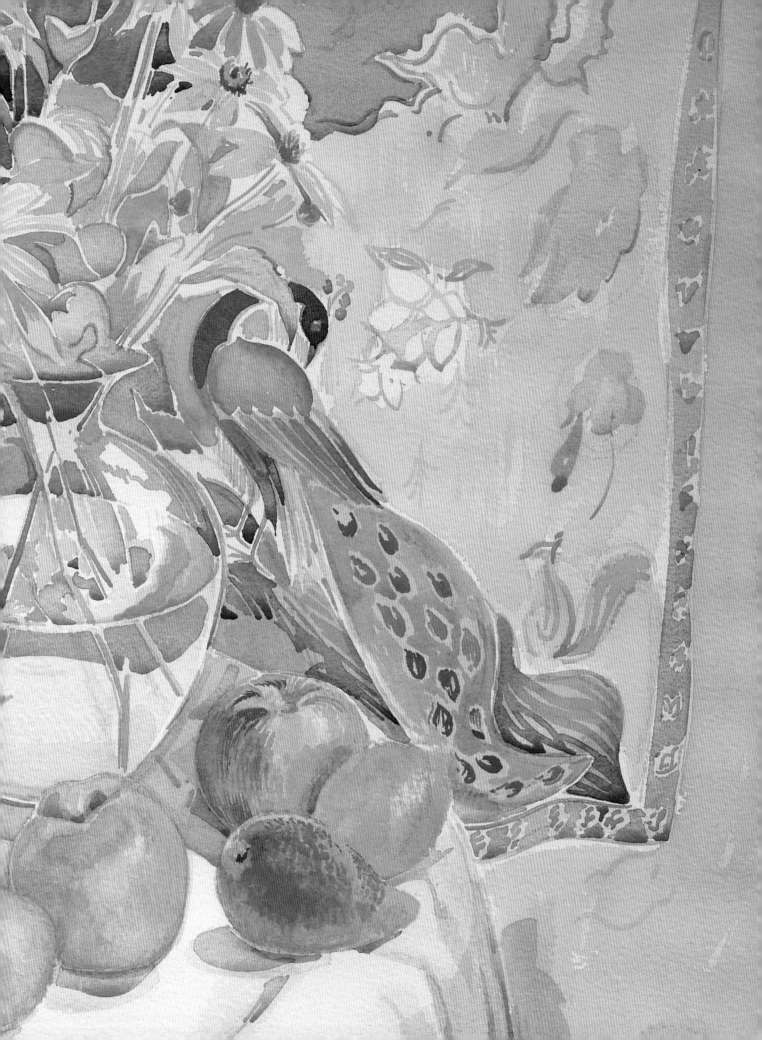

LILIES

The two paintings on pages 63 and 65 represent a completely different approach to still life. They are not painted in a context, but consist of two or more images which have been studied and drawn separately. In both cases, a background wash was prepared on the stretched paper. This wash, when dry, was then altered by means of colours added with a fixative diffuser.

In *Lilies and silverware* one study of lilies (previously done in pencil as shown on this page) and another of silver on a tray were painted on to this ground with watercolour and white gouache. The method continued, with alternate diffusions of watercolour and additional touches of the white gouache. Cardboard shapes were cut to mask parts of the design at various stages. Yellow ochre, Naples yellow, light red and Prussian blue were used in addition to the white. You will notice how some light decoration in Naples yellow shows through the darker diffused paint at the bottom right-hand corner. Masking fluid might have given a similar effect.

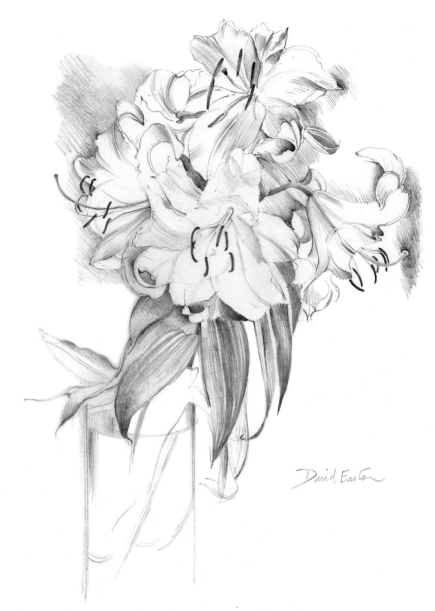

Lilies. Pencil, 28 x 23cm (11 x 9in)

(Right) *Lilies and silverware.* Watercolour and gouache, 61 x 46cm (24 x 18in)

(Previous page) *Still life with peacocks.* Watercolour, 51 x 63cm (20 x 25in)

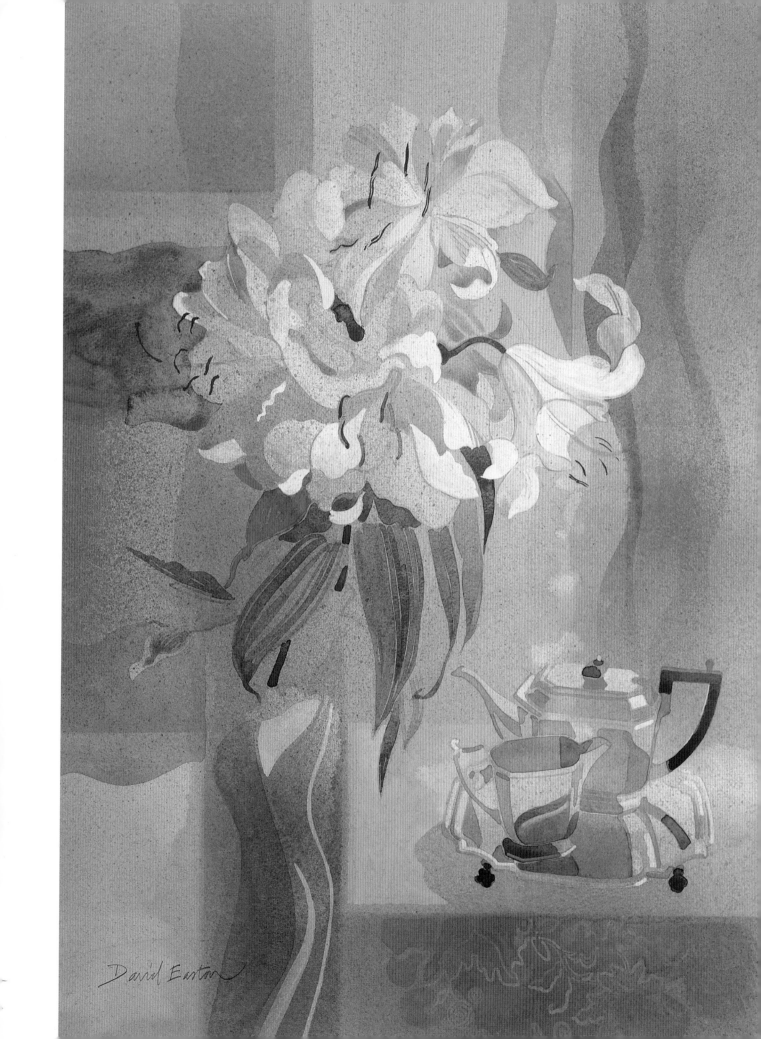

David Easton

The painting opposite, *Lilies and pineapple*, was made in much the same way as the previous painting. Cardboard masks were used for some of the shapes across the lower half of the square. A cool red was added to the colour scheme. Fine accents of white gouache were put in with a very long sickle-shaped brush. Some of these whites were then adjusted to creams or blue-white by means of diffusion. The pencil study shown on this page provided the lily forms. Studies like this continue to be valuable. I find that the time spent on them is amply repaid, both by the enjoyment in the making of them, and by their many applications. I have already adapted this sketch, and the one on page 62, as components in several paintings.

Lilies. Pencil, 31 x 24cm (12 x 9 ½in)

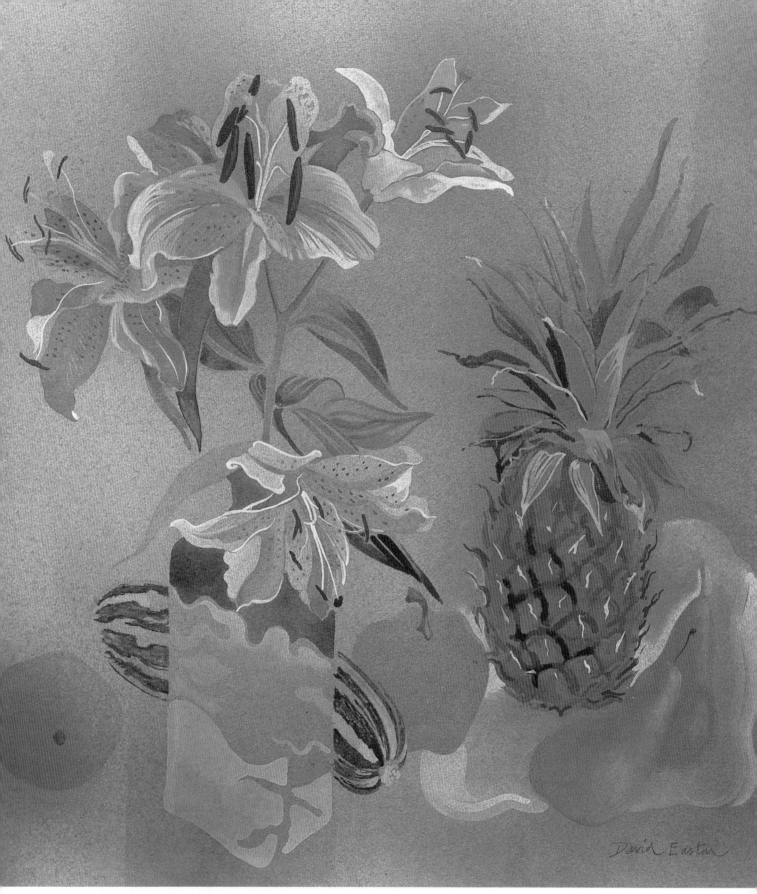

Lilies and pineapple. Watercolour and gouache, 54 x 54cm (21 x 21in)

Chapter Seven
LANDSCAPE INSPIRATIONS

FOREGROUNDS IN LANDSCAPE

Two landscapes used as introductory illustrations earlier (pages 2–3 and 6) are shown here along with the painting below. They are all examples of works where the foreground occupies a large part of the composition. The visual movement through these landscapes varies and this was significant in my choice of composition. You may notice that, where buildings are involved, I have found a gable end or a side which is parallel to the picture plane. This comes from an impulse to relate something in the composition to the rectangle, as an echo of the verticals and horizontals of the frame.

Croesor is painted in watercolour over ink lines. I liked the idea of two tracks, encouraging the viewer to explore the terrain, and the jagged slate wall in the centre. The drawing was done from the car, during a torrential rain storm. The colours are as a result understandably muted, although their range has been accentuated.

Above Black Rock caught my eye as a subject because of the large shapes. It divides very clearly into foreground, middle distance and the distant mountain. Here you advance into the picture either by the track on the right or by hopping from wall to cottage to mountain.

Farm at Cold Newton has some of these same characteristics, but it is more intricate. The drawing is more linear, with watercolour built over acrylic ink lines. The eye is led into the picture from the bottom right.

Croesor. Ink and watercolour, 25 x 35cm (10 x 13 ½in)

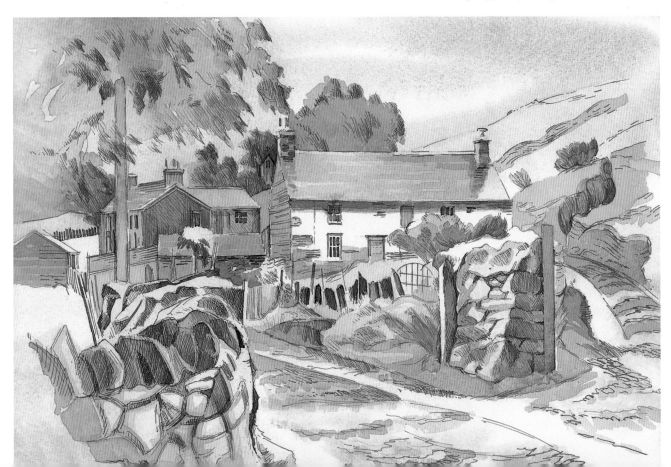

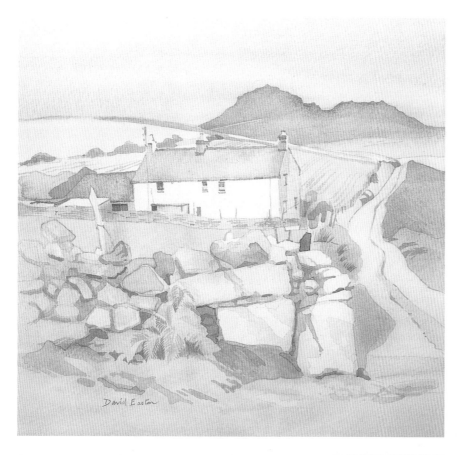

Above Black Rock. Watercolour on tinted paper, 28 x 28cm (11 x 11in)

Farm at Cold Newton. Inks and water-colour on grey paper, 28 x 36cm (11 x 14in)

THE PATTERN OF LANDSCAPE

Another aspect of landscape that fascinates and inspires me is the tapestry of fields and woods, usually viewed from a high vantage point. I like to establish foreground interest to lead into such a composition, to give perspective to the distant view.

Criccieth Castle is one of a great many sketches I have made in this area of North Wales. The pattern element is provided by the irregular growth of scrub on the steep cliffs. An evening light is giving a glow to the scene as the sun starts to drop behind the castle. This sketch was mostly painted wet-in-wet, with the darker shapes added after drying.

The sketch *Billesdon Coplow* was made in the studio from a drawing. It is on Chinese paper, which is very absorbent. Each brushmark spread, and the few finer lines had to be painted more dryly than usual. The effect is like a wet-in-wet painting.

Long Mynd is a watercolour done on the spot. I was attracted by the shape pattern and the crisp edges of the hills. These were changing rapidly as the low cloud rolled by, so there was no time for fine tuning.

Looking down on a valley near the Forest of Dean, I found an attractive pattern of trees in the landscape which I attempted to recreate in the pencil drawing shown here. This also shows the direction of a footpath across the fields. A painting based on this drawing might want to emphasize this path.

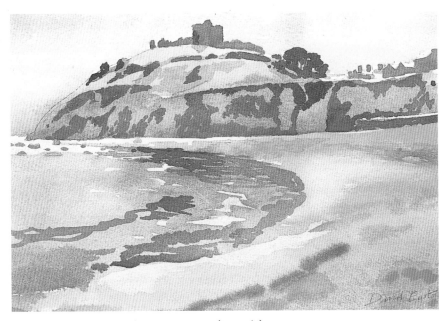

Criccieth Castle. Watercolour, 20 x 30cm (8 x 12in)

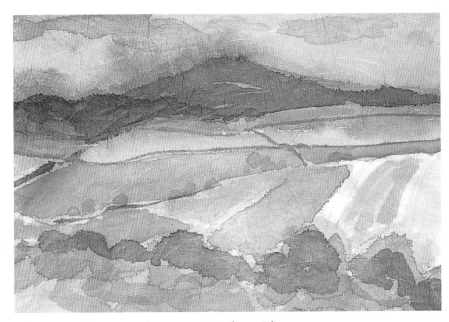

Billesdon Coplow. Watercolour, 20 x 28cm (8 x 11in)

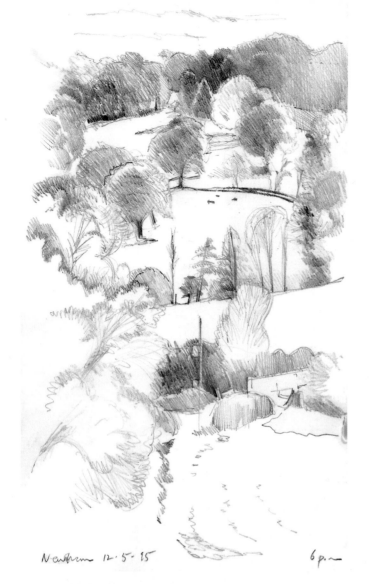

Landscape near Newnham. Pencil, 20 x 11cm (8 x 4 ½ in)

Newnham 12·5·85 6 p.m

Long Mynd. Watercolour, 28 x 41cm (11 x 16in)

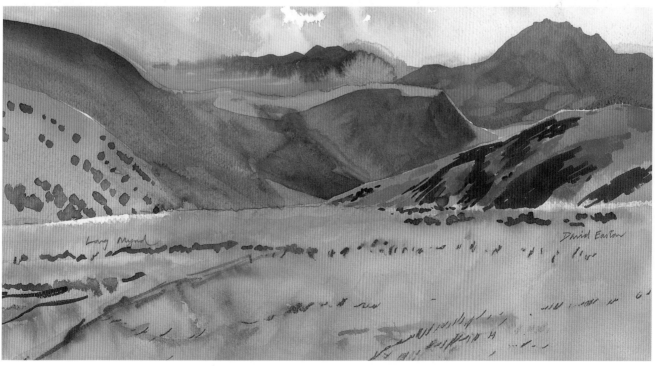

Long Mynd David Easton

FRANCE

I have made several visits to France with my wife Shirley. We have usually been tutoring on painting holidays, but have been able to do some of our own work from time to time, enjoying the rare experience of working in a warm climate. These two sketches are from similar viewpoints and were made in the south of France at the medieval village of Sauve. The ancient bridge is the interest focus. The sketch below was quickly painted over light pencil work on a block which was NOT surfaced (see page 120). The colour motivation here is cool shadow colours which interlock with the sunlit areas.

The work opposite, *Sauve*, which I spent more time on, is painted on handmade Arches paper from France. It has a soft pulpy texture, not conducive to lifting out. I kept the strong, dark accents to a minimum in order to retain the light presence. On a harder paper, I may have been tempted to work more detail into the buildings and this would have disturbed the balance which the quiet passage creates among the textures.

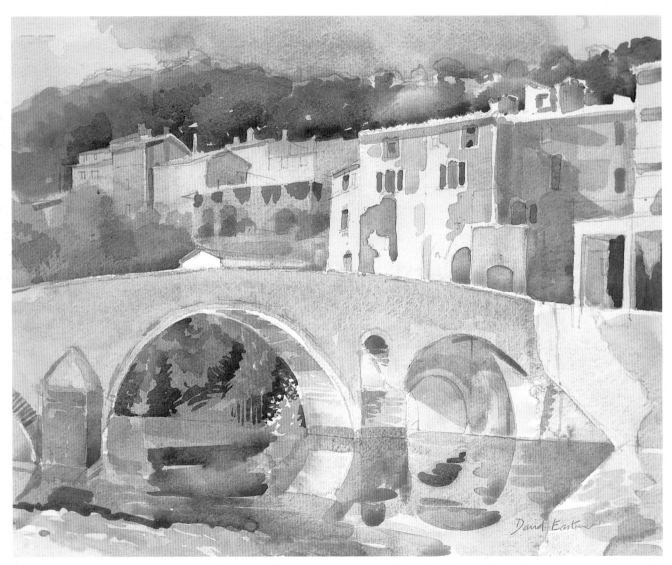

Sauve. Watercolour, 30 x 38cm (12 x 15in)

(Opposite) *Sauve.* Watercolour, 43 x 28cm (17 x 11in)

Houses at Vogue was not originally conceived as a square-shaped work. On this second version, painted from a drawing, I have deliberately played with the idea of the four corners of the square. Colour and light divide the top, and the two squares in the lower part of the painting, although positioned symmetrically, differ in shape and tone.

The sketch *Fruit Market, Aix,* is one of many rapid notes made in such locations. This time I used pencil crayons over the drawing, which was done with a brown fibre-tip pen. The brightly coloured gourds and sunflowers would have taken much longer to record in paint. I find this combination of media useful for gathering information quickly, and I only carry a few crayons. My current choices are: indigo and a lighter blue, yellow ochre and a cadmium yellow or similar, a red/orange and a crimson or magenta, burnt sienna, emerald green, and a white or cream for blending or heightening when working on toned papers. I prefer using Karisma coloured pencils. You will find other examples of their use on pages 96 and 106 (the colour range was extended a little here when working on the flowers).

There is plenty of information in a sketch of this type, and the inspiration to develop paintings using this reference may come after reviewing the sketches done on an intensive trip. Removed from the scene it is possible to concentrate on the composition and not be distracted by incidental details.

(Right) *Fruit market, Aix.* Ink and crayon, 26 x 21cm (10 x 8in)

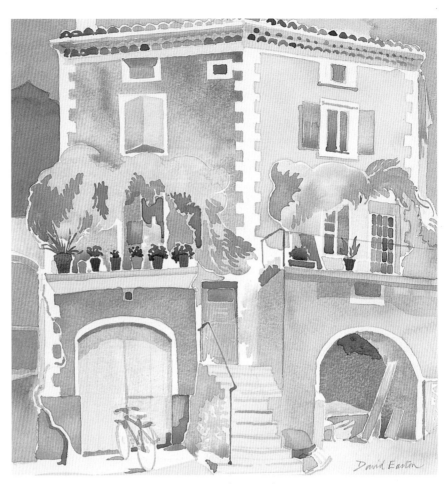

Houses at Vogue. Watercolour, 28 x 28cm (11 x 11in)

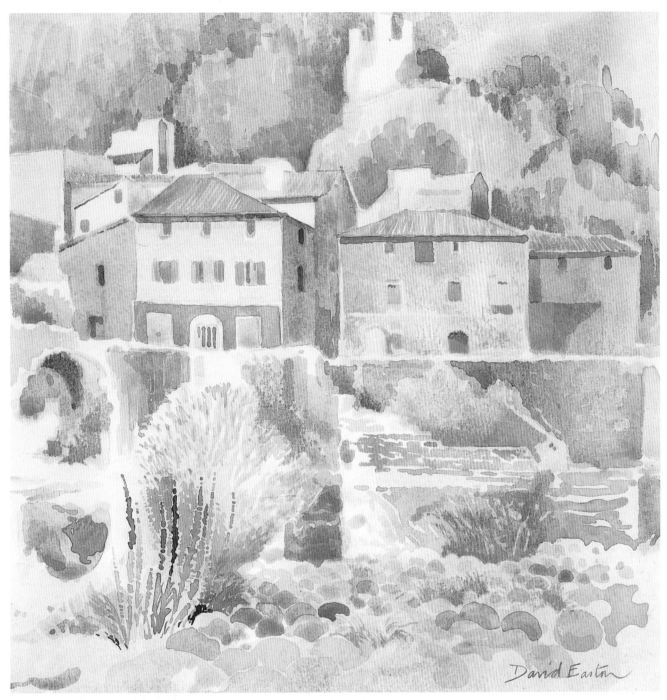

Village by the river. Watercolour, 28 x 28cm (11 x 11in)

Painted once again in the south of France, in the Ardeche village of Vogue, is *Village by the river* – another blocked frontal view. Most of the blue areas were established first, then the warmer colours were laid over the top. The houses are treated simply between the busy foreshore and the valley walls.

HARBOURS IN CORNWALL

The drawings and paintings on this and on the following two pages were all made on a visit to Cornwall. Most of the work had to be done from the car because of bad weather. Better weather on one day in the old harbour at Newlyn allowed me to produce the two paintings on this page.

Boats at Newlyn was painted in the studio on our return. I was able to make use of a sketch and (unusually for me) a photograph for this painting. The boats are in focus, with the complex backdrop of the town reduced to a very simple set of washes. Broken water reflections are sketched in over a light graded wash which, like the sky, is formed of blues and yellow ochre. Both these colours were laid in together at the start.

The old harbour, Newlyn was painted on the spot in watercolour and gouache on a grey pastel paper. When using a tall format it is important to break across the narrow dimension. The arcs of boat shapes and the ropes crossing the picture plane from side to side gave the composition linear tension. This is a more detailed version of the old harbour on page 121.

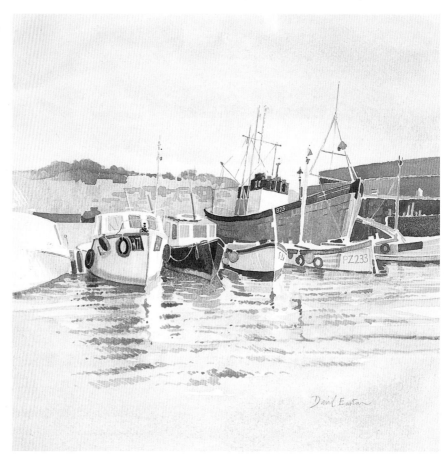

Boats at Newlyn. Watercolour, 33 x 33cm (13 x 13in)

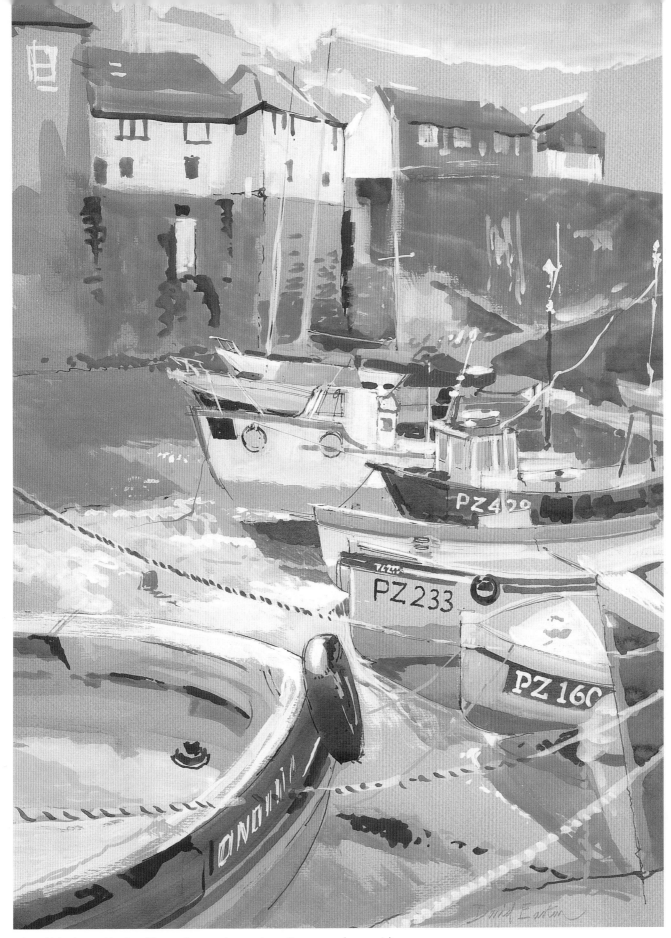

The old harbour, Newlyn. Watercolour and gouache, 48 x 33cm (19 x 13in)

The set of sketches on these pages was made from the stone pier at Mousehole, where I had to work on a small scale from behind the steering wheel. The first of these has been the basis for an acrylic painting. The watercolour was painted on location and 'tuned' in the studio, by means of lifting out as well as laying additional washes to accentuate the broad tonal divisions.

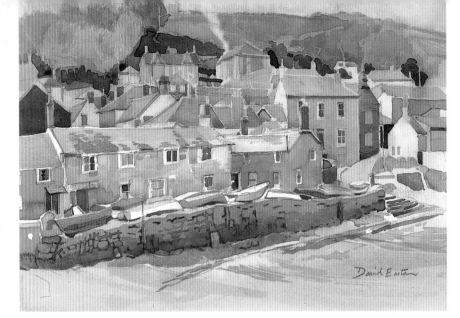

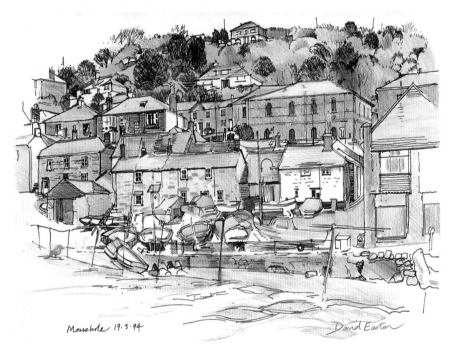

Mousehole 19.3.94 David Easton

(Top) *Mousehole.* Watercolour,
23 x 33cm (9 x 13in)

(Middle) *Mousehole.* Ink and crayon,
19 x 24cm (7½ x 9½in)

(Bottom) *Mousehole.* Ink and
watercolour, 19 x 24cm
(7½ x 9½in)

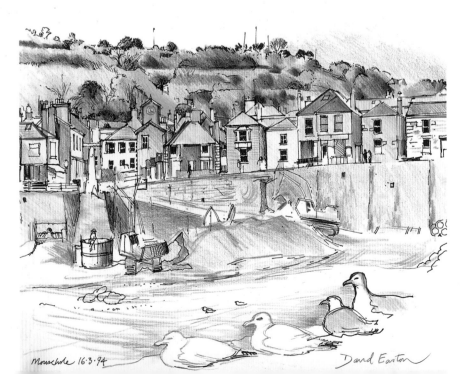

Mousehole 16.3.94 David Easton

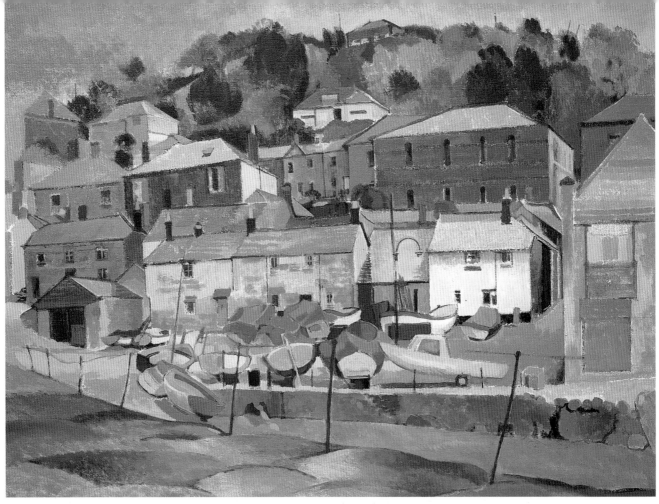

(Above) *Mousehole, Cornwall*. Acrylic, 51 x 61cm (20 x 24in)

(Below) *Mousehole, Cornwall*. Ink and crayon, 19 x 24cm (7½ x 9½in)

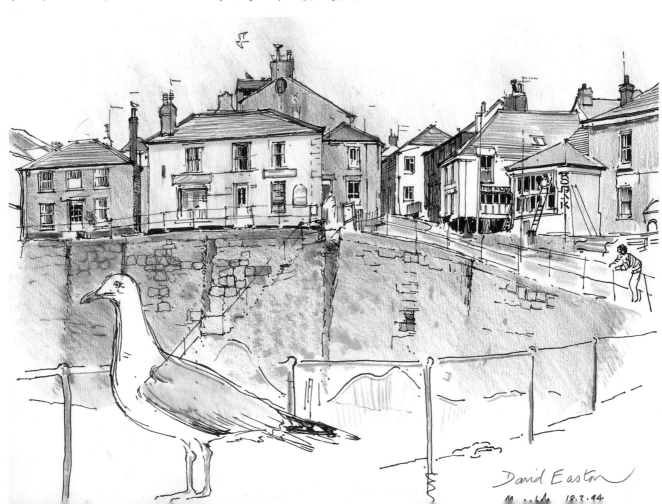

Chapter Eight
TREES

These pages show just a few of the ways in which I have responded to the inspiration of trees. The drawing below is in pen and wash on a watercolour paper. When the water is brushed in, picking up the unfixed ink from the pen line, the pigment behaves in a way which differs from work done on a smooth cartridge drawing paper. This quality is ideal for rendering foliage textures, as the brush collects enough dilute ink to enable parts of the drawing to be drawn with a softer emphasis, contrasting with the original sharper pen line.

Beeches, shown on the opposite page, is an acrylic ink and watercolour painting. The inspiration is drawn from shapes and intervals, and has taken on a restrained colour scheme. I was fascinated by the odd collection of abstract shapes enclosed at the end of this avenue.

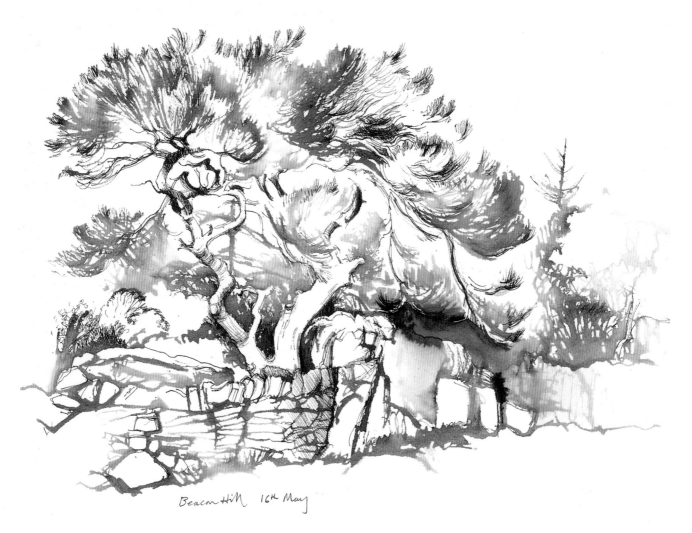

Autumn tree. Artpen and wash, 26 x 36cm (10 x 14in)

Beeches. Watercolour, 28 x 28cm (11 x 11in)

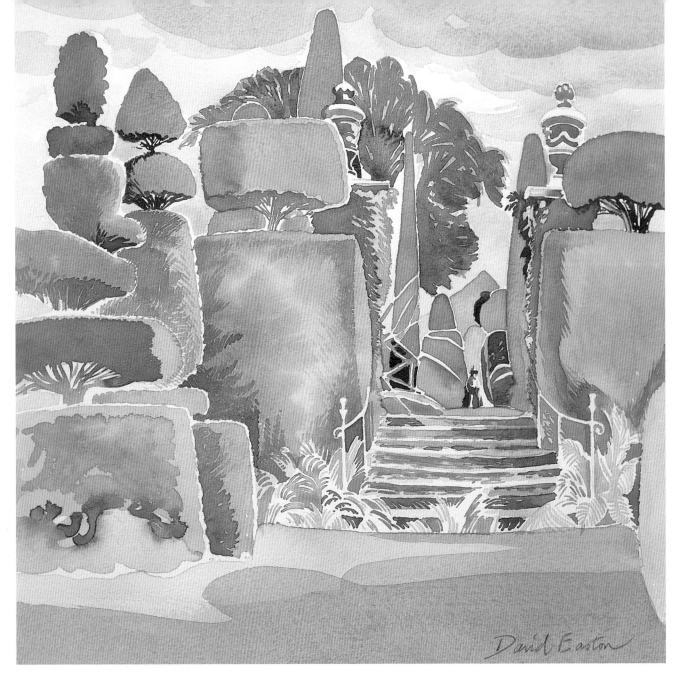

Topiary, Plas Brondanw. Watercolour, 33 x 33cm (13 x 13in)

Topiary is another style which appeals to me. I prefer the non-representational forms, such as these in *Topiary, Plas Brondanw.* A detail of this painting appears in the techniques section on page 17. I made a pencil drawing in this North Wales garden and painted the watercolour at home. The shape composition was followed closely, but simplified.

The Old Nest seen opposite is a watercolour painted on a tinted Bockingford paper, which helped to unify the warm colour scheme. The diagonal tree bole is the main active element in a composition that otherwise has no focal points. The painting is really about the sensational effect of light shining through the foliage of a small tree in autumn. An old bird's nest makes a useful focus and is just about the only horizontal form among all the spreading branches.

The old nest. Watercolour on tinted Bockingford paper, 33 x 33cm (13 x 13in)

AUTUMN COLOUR

The seasonal colour is clearly the link in these four sketches which I group under the collective heading *Trees in Autumn. Batsford Arboretum* is in watercolour on a Two Rivers tinted paper. The warm paper tone helped to unify the diverse colours of the foliage in this work.

Glade at Batsford was another of the direct sketches done at this inspiring location. It shows a rather odd collection of tree forms and a statue.

The two crayon drawings are studies of groups of trees in my own locality. The young plantings of an arboretum are set against mature trees, forming fascinating juxtapositions of shape and colour. A little watercolour has been touched on to the sketch below. I have produced large pastels from these two studies and others in a series. They remain helpful as reference for potential future works, probably in watercolour. When using them in such a way, it is important to register the scale of the motif. It is actually quite difficult to enlarge a colourful sketch and to keep control of the balance. Do not always assume that a translation into paint will involve enlargement of the image.

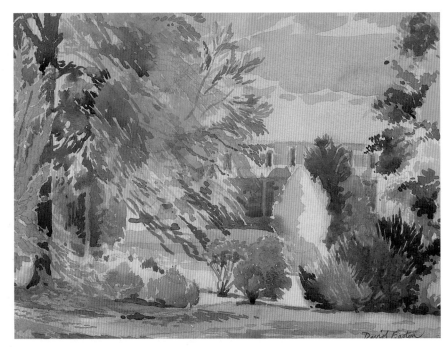

Batsford Arboretum. Watercolour, 26 x 36cm (10 x 14in)

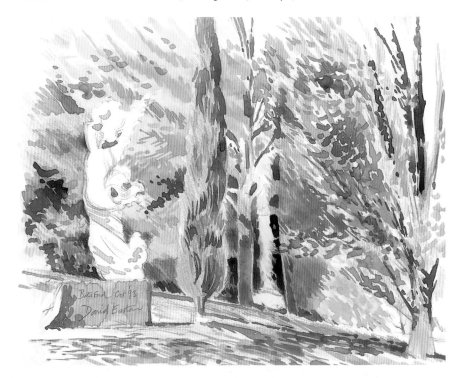

Glade at Batsford. Watercolour, 18 x 23cm (7 x 9in)

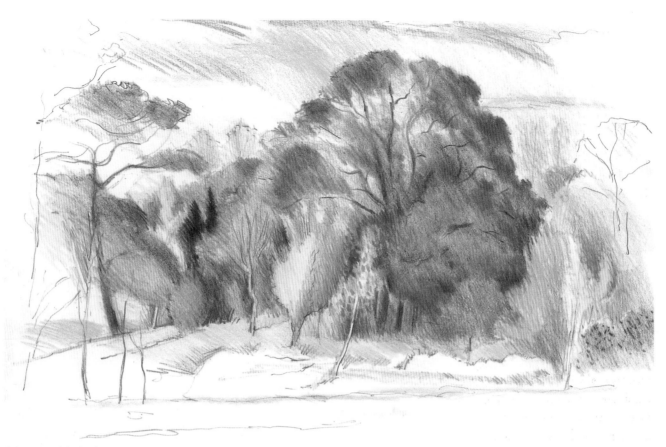

(Above and below) *Evington.* Crayon on Ivorex board, 18 x 24cm (7 x 9½in)

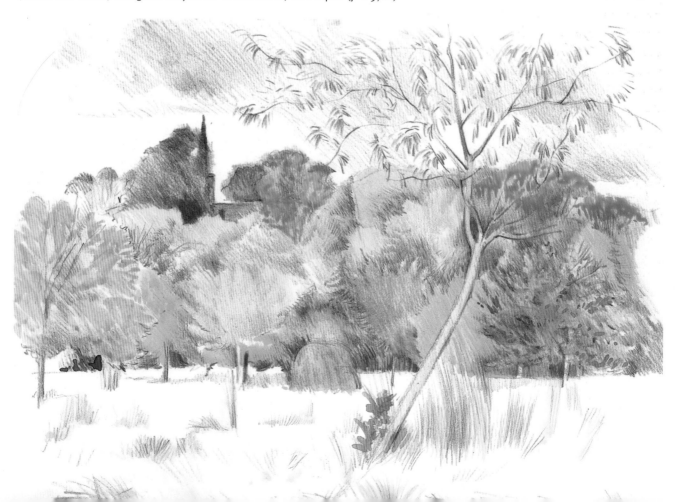

Chapter Nine
GARDENS

I could not leave our own garden out of this book because it has been the source of much inspiration over the years for both Shirley and myself. This applies equally to the garden as a whole and as a source of individual flower studies in context or in the studio.

We also see our garden through the eyes of student friends who paint here on occasion during the summer months. They often come up with ideas that had escaped our notice, which is a further encouragement to look again at this familiar subject.

The garden in August shown here is a large watercolour painted over several days in short sessions. In a painting of this size and complexity,

I will usually start by mapping out the positions of the main structures with light pencil marks, such as the buildings and tree shapes. All the flowing natural leaf and flower forms are made directly with the brush.

There is no overall wash, but substantial areas of light colour were blocked in on the wet paper. I found that the painting began to read in alternating patches of soft and sharper focus. I encouraged the effect by leaving areas, such as the blue-green foliage at the bottom left, light and open.

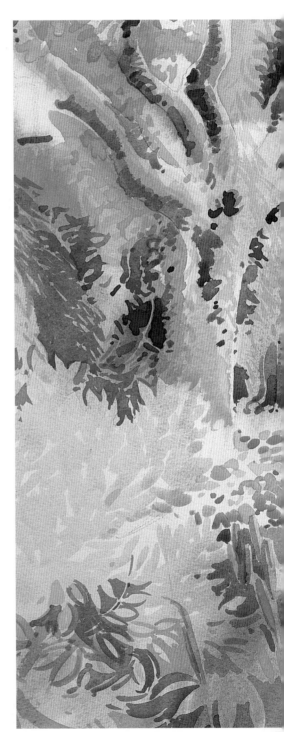

The garden in August. Watercolour, 51 x 66cm (20 x 26in)

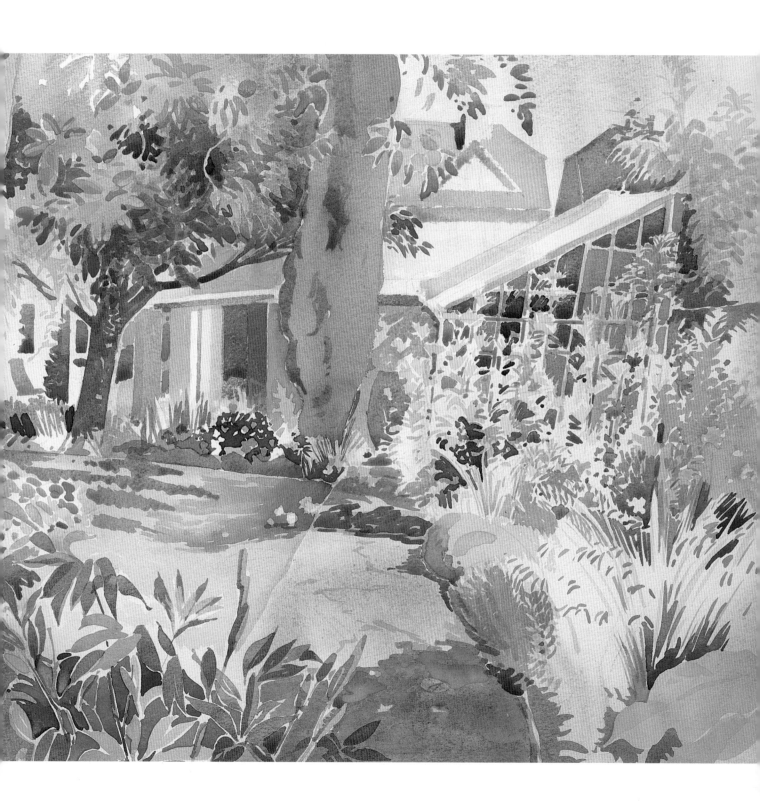

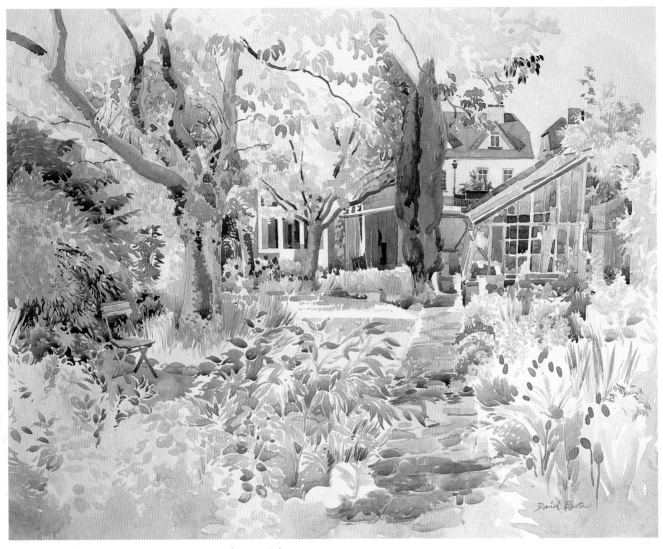

The garden in May. Watercolour, 51 x 61cm (20 x 26in)

The *garden in May* seen from almost the same aspect as the painting on pages 84 and 85, has a different balance of tone and colour as befitted the season. The advantage of being able to pace the work over a week, while working on indoor motifs in between, is that each set of marks can dry out. This contributes to the clarity in sections of the diverse foliage.

Spring garden is a painting composed from sketches, together with sessions in front of the motif. In consequence it has a more consciously organized design.

The painting was in fact especially made for a magazine article, in which I also showed the supporting material.

It is useful to be given a project from time to time or to set yourself a problem to solve. Why not take something close at hand in your own environment, explore it through drawings and colour studies, and put yourself through the discipline of assembling a composition? It is a process that can bring you insights that are quite different from those found through working in the more usual direct ways.

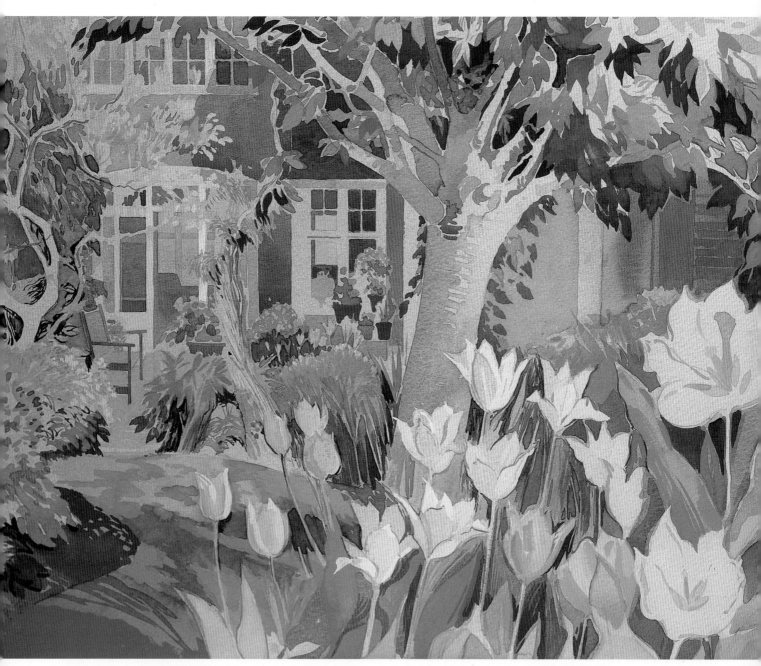

Spring garden. Watercolour and gouache, 38 x 48cm (15 x 19in)

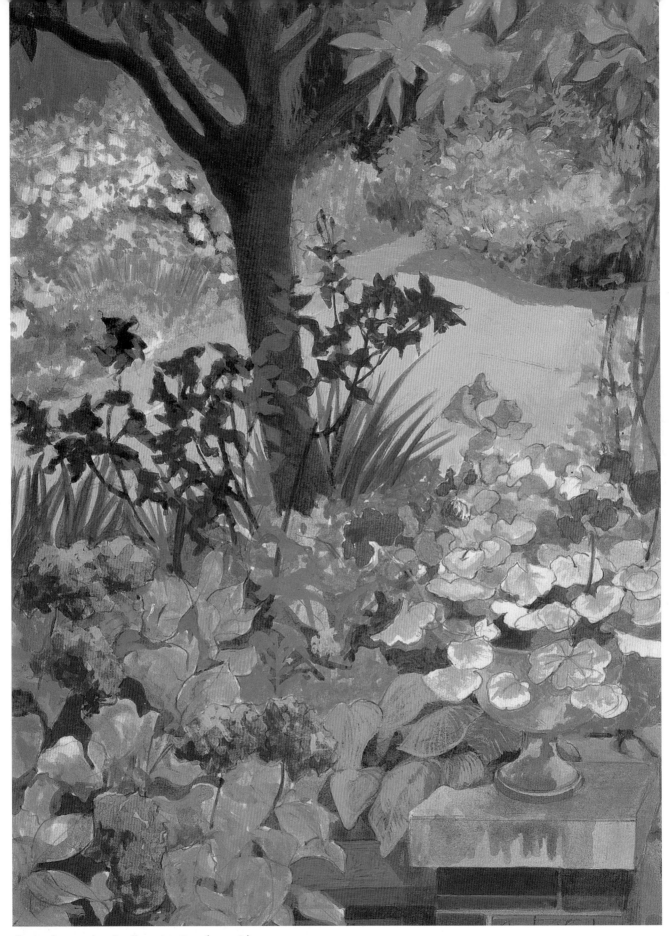

September garden. Acrylic, 25 x 18cm (10 x 7in)

My wife has painted the garden many times, and these three paintings of hers, each quite small, show a similar preoccupation with design. Each work has been preceded by sketchbook studies.

September garden is richly painted in acrylics, mostly applied in transparent washes. The silhouetted tree and leaves effectively separate the two distinct rooms of the garden.

Petunia corner is a watercolour of a subject found in a shaded part of the garden. A varied collection of foliage forms, all in muted greens, gives a complementary setting for the brighter coloured flowers.

December frost represents a very appropriate use of white acrylic ink over the restrained washes of watercolour. Painted from the window, it features the trunk and branches of a magnolia tree, which has been an inspiration for many pieces.

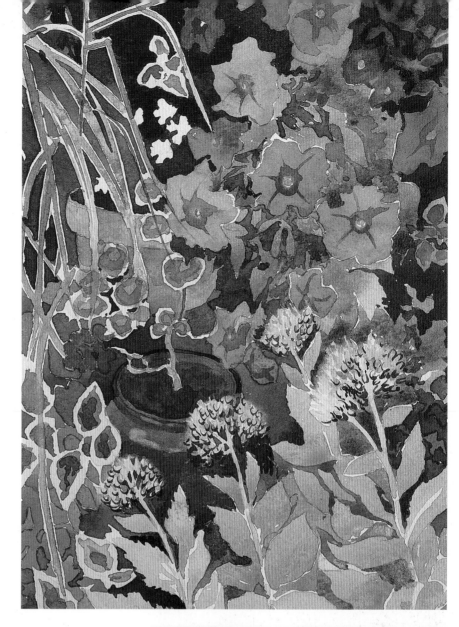

(Above) *Petunia corner.* Watercolour, 20 x 15cm (8 x 6in)

(Right) *December frost.* Watercolour and acrylic inks, 20 x 15cm (8 x 6in)

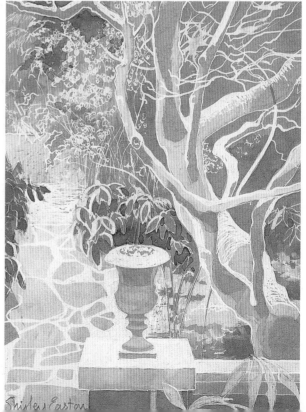

Chapter Ten
FLOWERS

MONTAGES

The first set of paintings in this chapter includes studies arranged to make a composition with few or no other objects. *Irises and flags* and *Amaryllis studies* come into this category. Both studies were composed on full sheets of HP watercolour paper, the former in watercolour, and the latter in mixed media. The placing of each element was determined as the work progressed, in relation to the spaces left and the balance of the arrangement.

Other paintings in this section were painted from several viewpoints in the garden, or from indoor flower studies. In each case I started by establishing some of the larger flower shapes.

Spring border, from which details are shown on pages 8–9 and 24, and *White tulips* (overleaf) were painted in the same week. They were both inspired by the abundance of new plant life that follows a long winter. This scale encourages a broad approach when working close to the motif. These two paintings have a flat pattern quality.

For my still lifes and landscapes, I invariably make a composition that breaks out of the rectangle. In contrast, many of my flower paintings are contained within a more irregular shape. In these cases I am always very particular about the exact position of the mount. The space around the image is a vital part of the design.

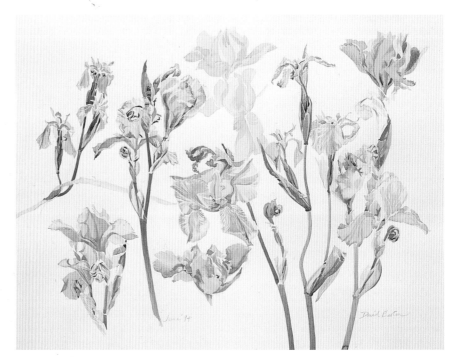

Irises and flags. Watercolour, 76 x 51cm (30 x 20in)

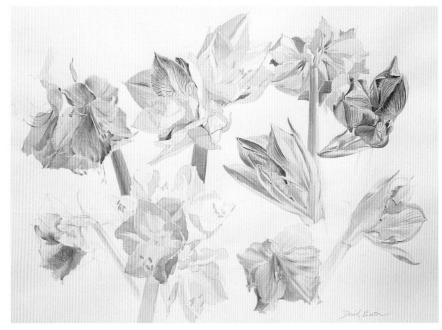

Amaryllis studies. Mixed media, 76 x 51cm (30 x 20in)

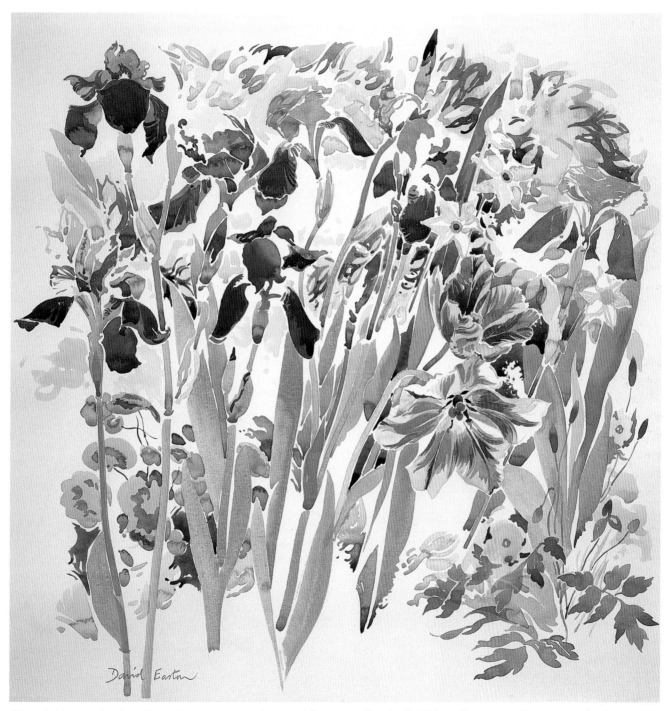

(Above) *Irises and tulips.* Watercolour, 51 x 51cm (20 x 20in) (Overleaf) *White tulips.* Watercolour, 51 x 66cm (20 x 26in)

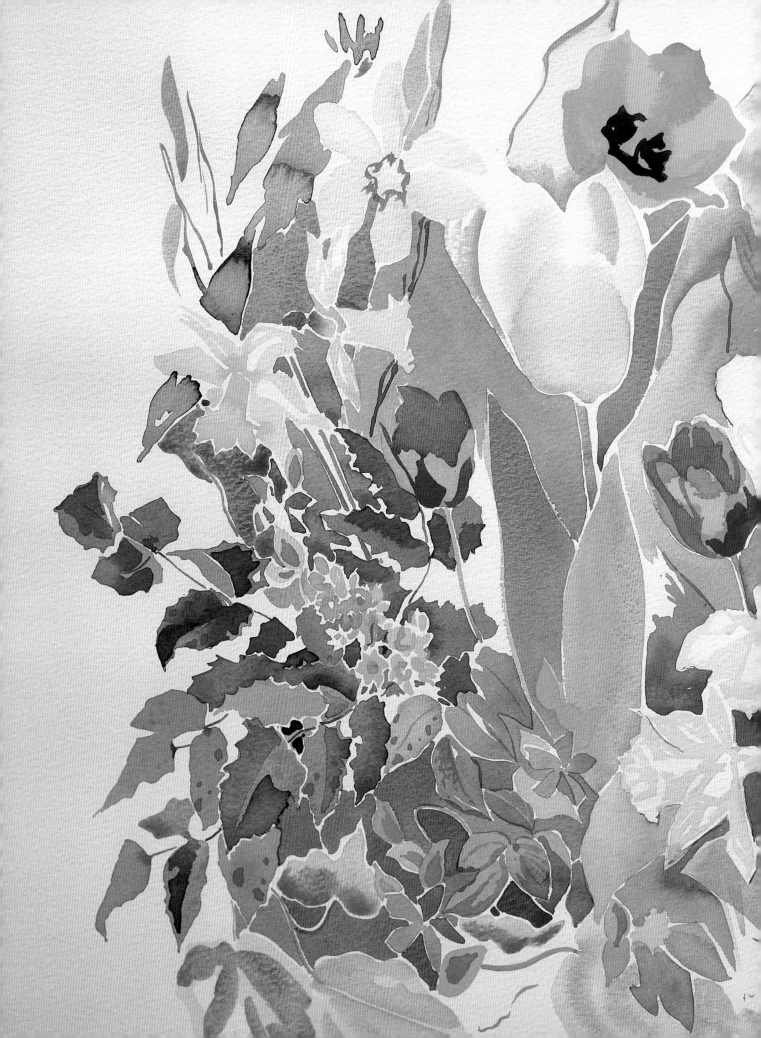

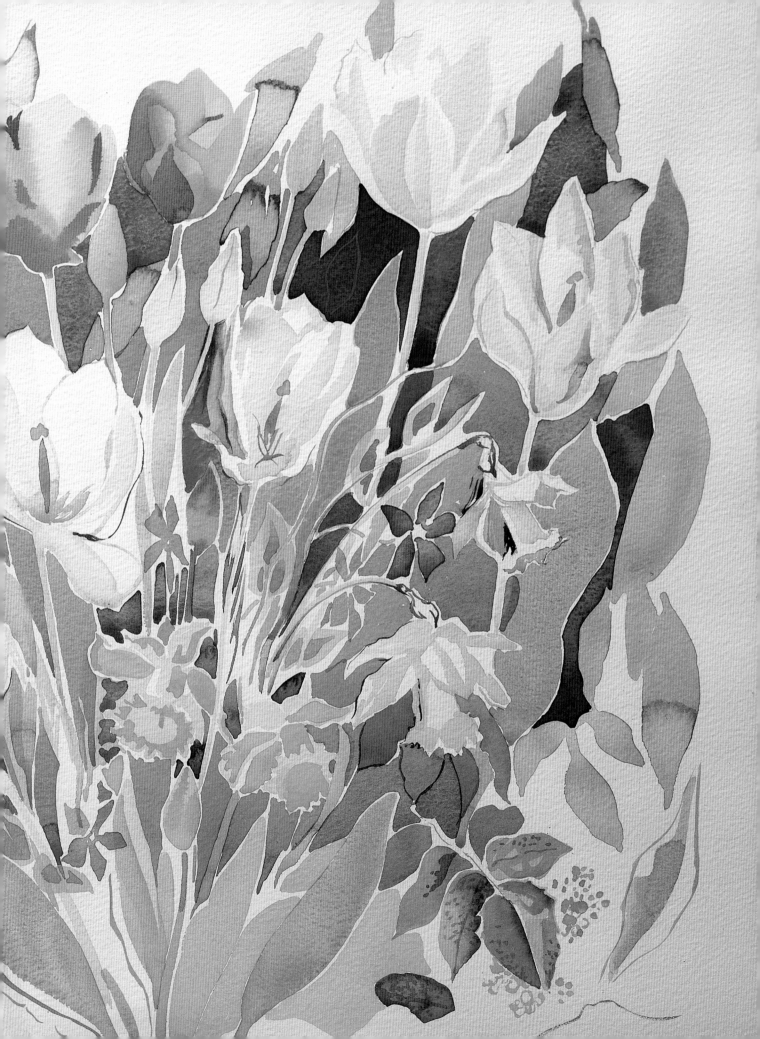

CONTRASTING METHODS

These two flower paintings are put together at this point to illustrate two very different ways of working. Both methods will be in evidence in the following pages.

Autumn flowers was painted on a ground prepared by methods described on page 62. On this base, transparent watercolour has been built up to a rich depth of colour. The work then continued with white gouache and diffused versions of the pigments used for the initial washes. I tend to use this technique for work not done in front of the subject.

June flowers opposite was painted along with the picture on page 91 (of which a detail is shown on page 13). In the spirit of the montage paintings, they involve a very delicate balance between the painted marks and the white paper. The white enters the heart of the piece where the narcissi are keyed by the stronger tones of leaf and petal behind. The purple irises provide the dominant colour and tone. In this painting the container is barely suggested and it is the tight group of stems that gives the effect of the bunch.

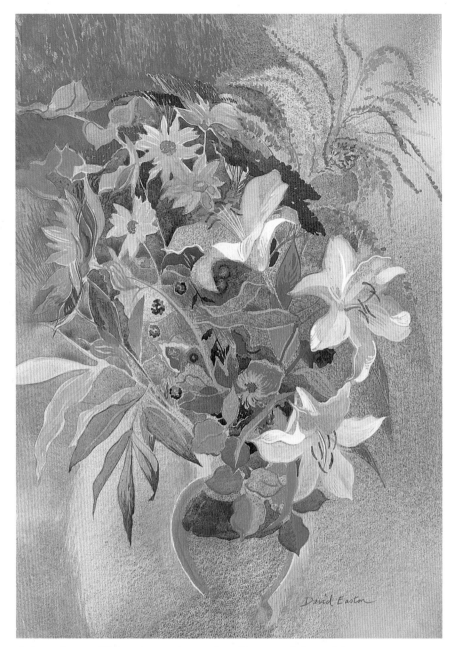

Autumn flowers. Watercolour and gouache, 66 x 51cm (26 x 20in)

(Opposite) *June flowers*. Watercolour, 54 x 54cm (21 x 21in)

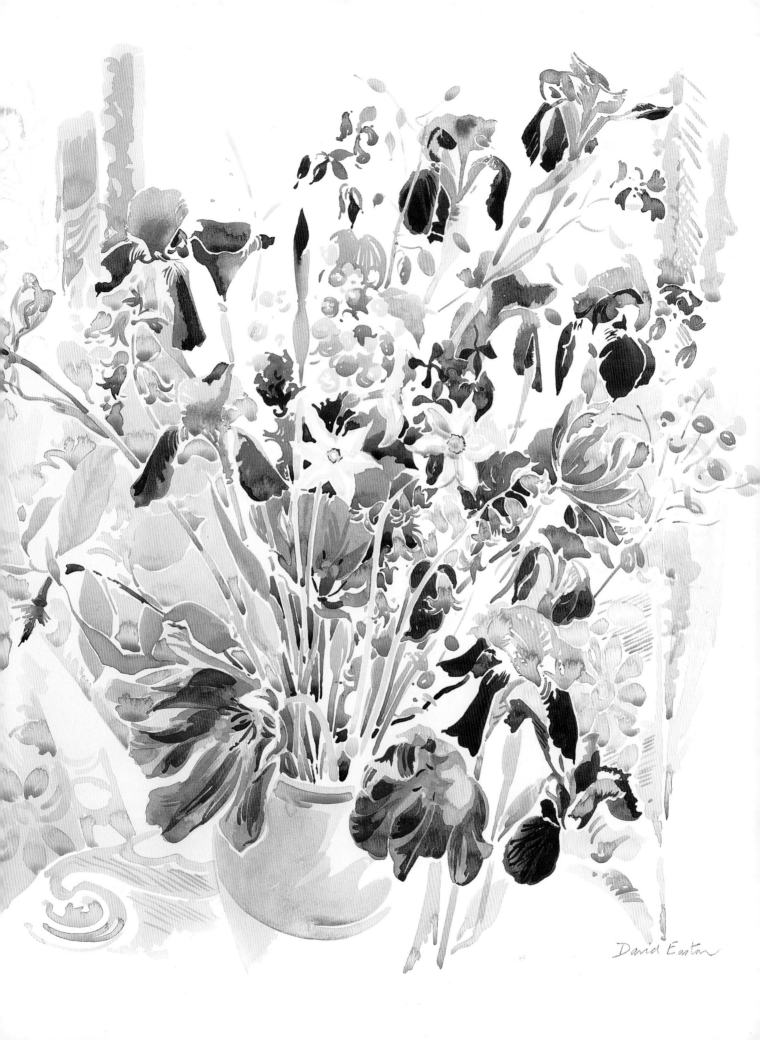

David Easton

MAGNOLIAS

The study of magnolias on this page is in pencil and crayon, with watercolour for the leaves and woody parts. The pencil lines define the edges selectively. Cream crayon was used to blend the reds and greys. These pencil crayons work well with watercolour; they can be used in 'washes' and in a similar way to glazes. This can be especially useful when light colours are laid over darker ones to unify, blend or simply to reduce the tonal strength.

The painting *Magnolias* was made directly from a branch set up in the studio. The background was prepared in advance with a watercolour wash where three pigments were mixed in generous amounts. They were then poured on to the evenly wet surface at various points. The blending of these pigments was achieved by tilting the board at angles to allow the colours to run together. This is a tricky manoeuvre, as you have to avoid runs of colour getting out of control. This seamless effect is not always desirable, but in this case I required a simple colour shift as the setting for the complicated flower forms.

It is surprising how readily the transparent watercolour takes on the pigmented ground, as long as you avoid putting the brush back into wet shapes and stirring the colour up. There was need for only a small amount of white to pick out the lower flowers.

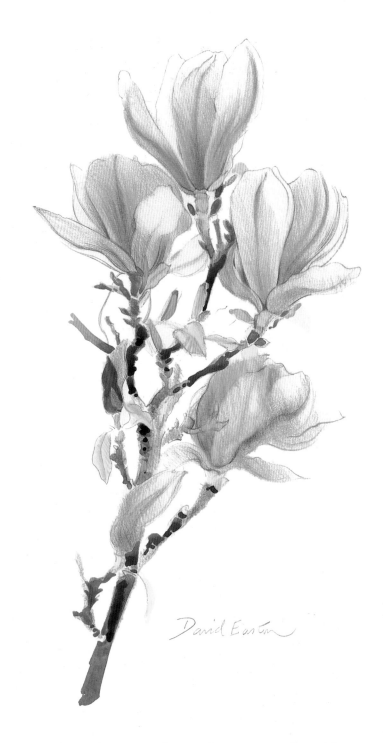

Magnolia study. Pencil, crayon, and watercolour, 31 x 18cm (12 x 7in)

(Right) *Magnolias.* Watercolour and gouache, 66 x 51cm (26 x 20in)

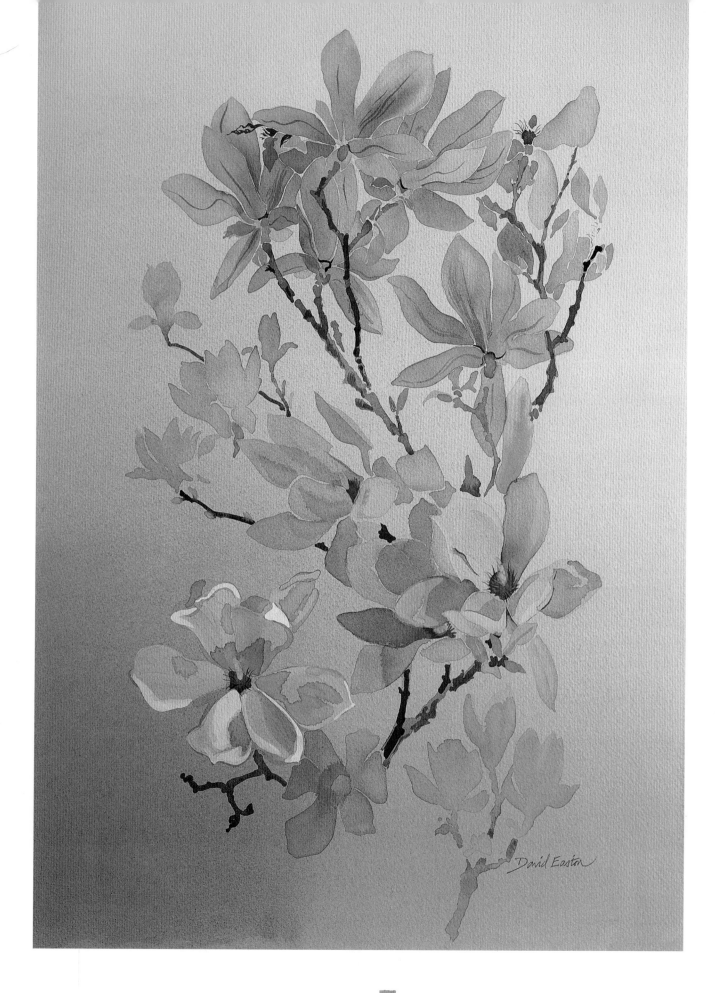

David Easton

CYCLAMEN

The cyclamen plant appeals to me in several ways. The foliage is clear-cut, often pleasingly variegated, and grows in a sculptural form of planes. The flowers, whether white or in a range of pinks, contrast sharply with the leaves. I prefer to paint them when some flowers have descended among the leaves.

The gouache study shown on this page, on a grey pastel paper, uses a range of pigments in the search for an accurate match for the intense red/violets of the cyclamen flowers. In the interests of harmony, magenta is also used in the mixes for the darker shadow areas in the leaves. Peachy colours have been brought in to adjust the grey paper in response to a warm light behind the plant.

The pencil drawing, a carefully observed study, was traced lightly on a background which was prepared as for *Magnolias* (see page 97).

Cyclamen and plate is again in watercolour, with more use of gouache. This setting is an imagined one, with the plate derived from a photograph in a book of ceramics. The vertical passages of colour suggest a wall and a piece of lacy fabric.

A more traditional painting of a cyclamen, all in transparent paint is shown in a detail on page 16. The linear diversity of cyclamen plants is seen in the pen drawing on page 42.

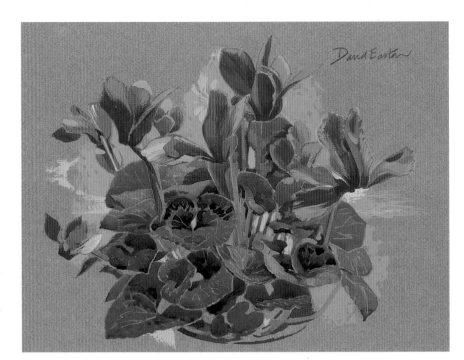

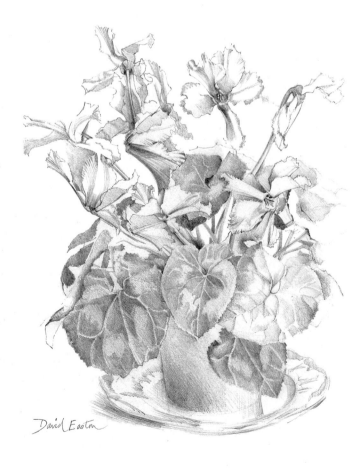

(Top) *Cyclamen.* Gouache, 23 x 28cm (9 x 11in)

(Right) *Cyclamen.* Pencil, 33 x 26cm (13 x 10in)

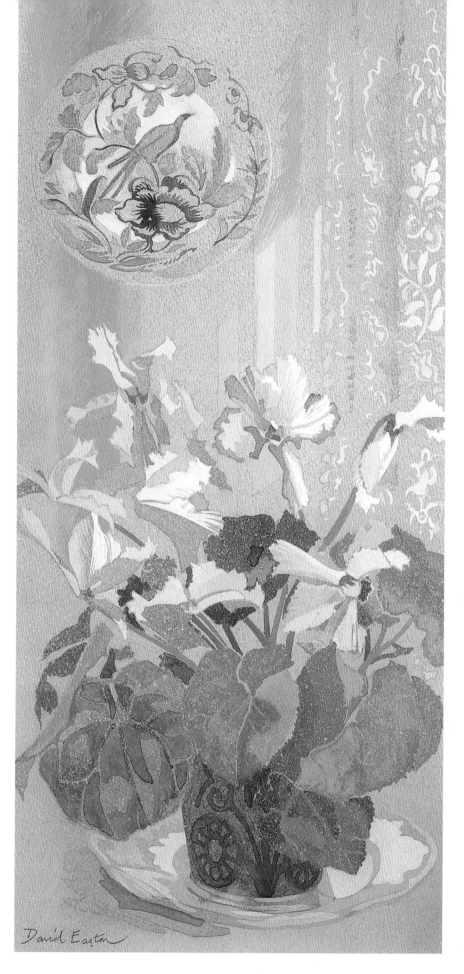

Cyclamen and plate. Watercolour and gouache, 51 x 25cm (20 x 10in)

IRISES

If I had to select a favourite flower, it would be the iris. You will find several other iris images on pages 13, 19, 91 and 95. My inspiration comes from the flower forms, which present great variety as the three stages of growth can be seen on the same stem. The buds, full blooms and the shrivelled old flowers all contribute to a fascinating structure.

These two paintings are clearly of the same pair of iris types, but they differ in technique and effect. *Iris study* is in gouache on brown pastel paper. The thick pigment gives the yellow flowers more substance. Brush line is used in defining these against the paper tone and in carrying the darker flower colours into the design.

Iris composition started with direct watercolour painting in the garden, as with some of the earlier montage paintings. It is on cream Bockingford paper. When the flowers and leaves were completed, I used the same pigments to diffuse colour over the work. It was not necessary to mask the flowers, as they were only receiving a little more of the same colours. The purples were slightly muted by yellows, but this added to the harmony.

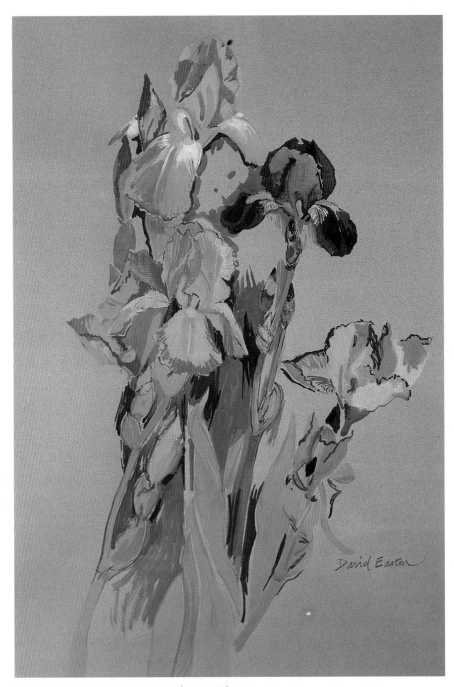

Iris study. Gouache, 46 x 30cm (18 x 12in)

The composition has been organised and manipulated in order to achieve a satisfying balance. This involved looking at the motif from several viewpoints. The darker flowers are placed to take the viewer on a journey across the picture plane. The yellow flowers form a subsidiary theme. Foliage and stems divide the setting, with the negative spaces receiving equal consideration. The process of diffusing yellows, blues and red/violets offers a high degree of control. I have sought to give an impression of space by varying the colour balance in the setting, and the clarity of the flowers and foliage. The detail on the right shows the effect of diffusing over the initial washes.

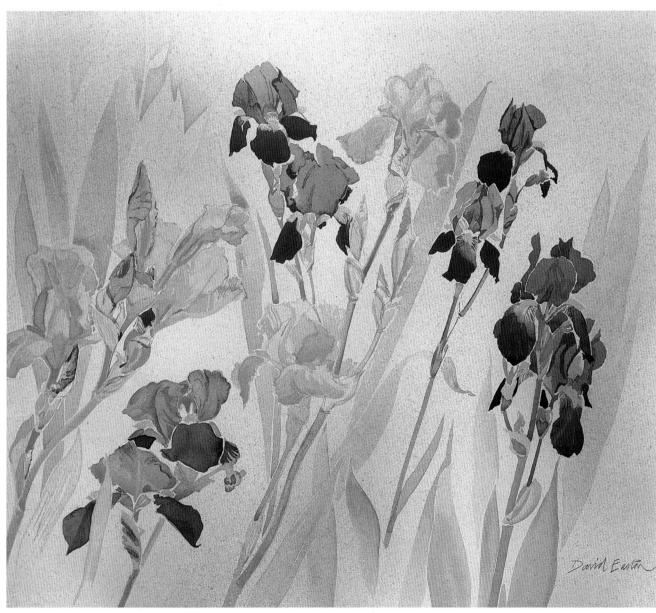

Iris composition. Watercolour and gouache, 51 x 66cm (20 x 26in)

This set of work shows a simple translation of two studies into a watercolour painting. The studies are in coloured crayons and they record some of the attributes of the flowers which are noted on page 100. I recommend the practice of drawing directly with colour as a variation from starting with a graphite pencil. Depending on the motif, it can be very constructive to get straight to the colour, using the crayons like dry watercolours as described in relation to the magnolia drawing (see page 96). All these studies add up to an invaluable resource and can be used in many combinations or styles of painting.

The studies have been traced on to an HP sheet, and the painting *Irises* made with the studies propped up for reference. You will notice that a couple of other studies were used to complete the design. They have been painted wet-in-wet, taking them behind the main flower stems. Cobalt blue was useful for the basic colour of the flowers, but I followed my frequent strategy of touching in cerulean where they tended towards green and ultramarine for deeper tones and more violet blues. This bracketing of the dominant colour is useful in other ways. The various pigments create different nuances of tertiary colour when they combine with their near complementaries.

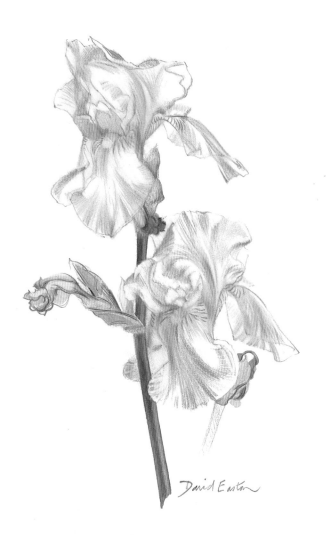

Irises. Crayon, 31 x 18cm (12 x 7in)

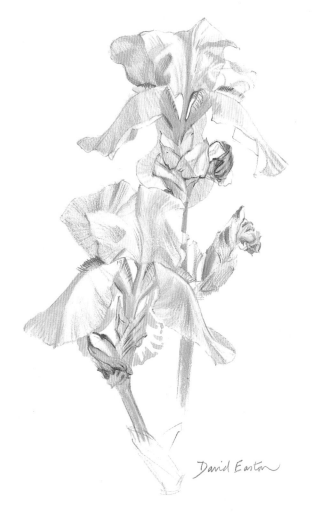

Irises. Crayon, 31 x 18cm (12 x 7in)

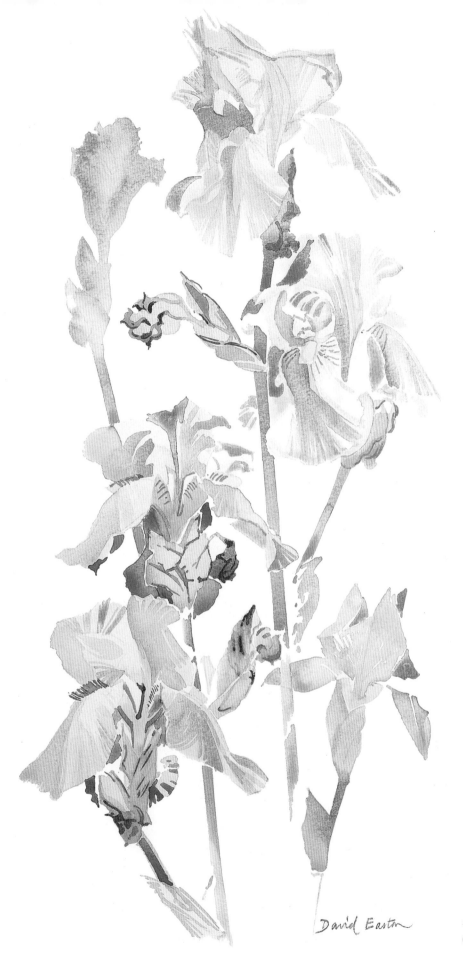

David Easton

Irises. Watercolour, 51 x 25cm
(20 x 10in)

HYDRANGEAS

In these paintings of hydrangeas, the challenge and inspiration come essentially from different colour and tone relationships.

For *White hydrangeas* I began at the top and worked down the page, viewing the plant from a different angle. This type of exercise can lead to work that is less dominated by the detail of the setting. There is a lightness about the flowerheads, with the forms suggested only in part by painting some petals in shadow. The white areas are adjusted with pale creamy-yellows here and there, as part of the warm and cold colour interplay. The foliage contains much more contrast of colour and tone than the flowers.

Violet hydrangeas presented different problems. It started out as a very detailed pencil drawing on HP paper. I had intended to complete it as a tonal study, but took the plunge and painted some flower colours. These very assertive colours contrast quite harshly with the greens. I emphasized the blueness in the leaves and played down the yellow/greens. The fascination grew in the sorting out of the many directions and veinings within the foliage.

It is essential not to give an even pattern of detail when you are painting flowers and plants. In this case, the understated leaves enhance the value and effectiveness of the more detailed ones.

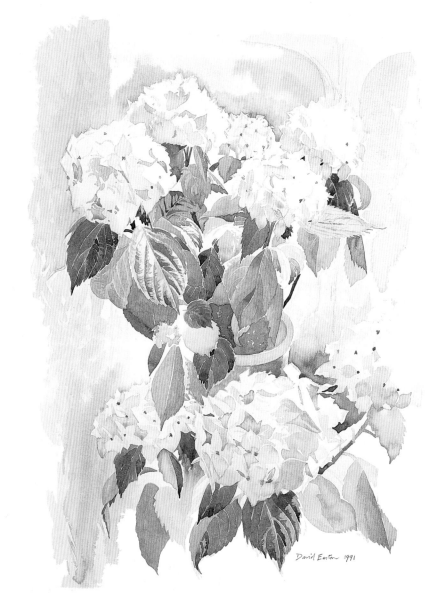

White hydrangeas. Watercolour, 61 x 46cm (24 x 18in)

(Opposite) *Violet hydrangeas.* Watercolour, 46 x 30cm (18 x 12in)

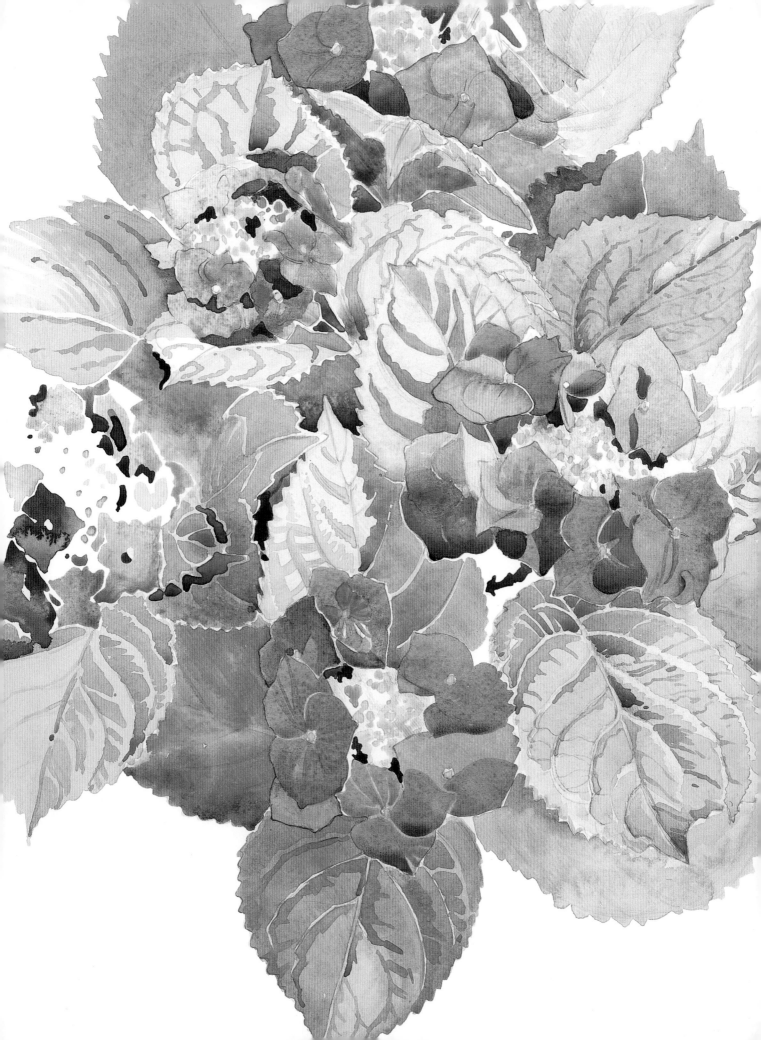

POPPIES

The day when the oriental poppies bloom is always exciting. This is another flower that seems to be endlessly varied in form and I never tire of making studies. Those shown below are typical examples, although I do make direct watercolour studies as well.

Poppy garden was painted on a tinted Bockingford paper and was assembled from sketches. I began by placing the flowerheads, then painting them yellow, then orange and red. The underlying yellows give the flowers that special brightness when they shine through. It can be more evident on very white papers. Lighter stems and foliage were painted in this early part of the process and the darker elements built up in between. The dark purple accents were put in last of all.

The red/orange of poppies is a difficult colour to put in context with other colours. Part of my inspiration has been about finding variations on the theme, many of which have led me to put the emphasis on neutrals in the settings. In general, it is a good principle to find colours that are part of the make-up in both the flowers and the foliage or other elements of the setting.

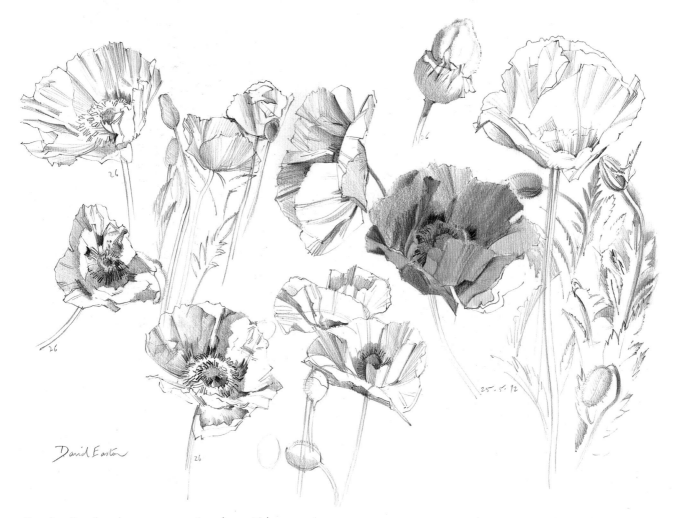

Poppies. Pencil and crayon, 31 x 46cm (12 x 18in)

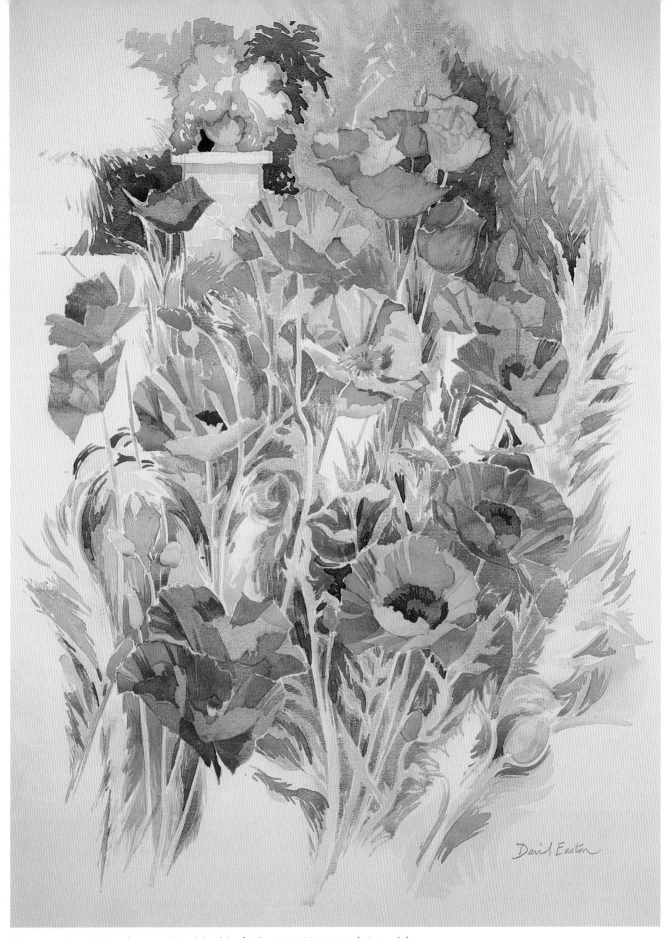

Poppy garden. Watercolour on tinted Bockingford paper, 66 x 51cm (26 x 20in)

Chapter Eleven
NATURAL FORMS

The particular emphasis in this chapter is on a different set of work. These paintings do not exactly fall into the categories of still life, landscape or flowers, though they may have connections with each. They are works which are principally motivated by form.

Many artists collect shells, stones, bones, driftwood, and dry vegetable matter such as seedcases, seeing them as desirable objects in their own right. They also find inspiration in the forms, which have influenced notable sculptors such as Henry Moore.

Shellscape is a watercolour painted on a tinted Bockingford paper. The preparation for this work was carefully planned. A group of objects was set up on a drawing board, with a sand-coloured paper as a base. A sight-size drawing was made, squared up to twice its size and transferred to the larger paper. This enabled me to complete the work in front of the motif without having problems with the scale.

The concept is somewhere between a still life and a landscape. I like to think of it as a controlled landscape where all the elements are chosen and placed for painting.

Shellscape. Watercolour, 25 x 51cm (10 x 20in)

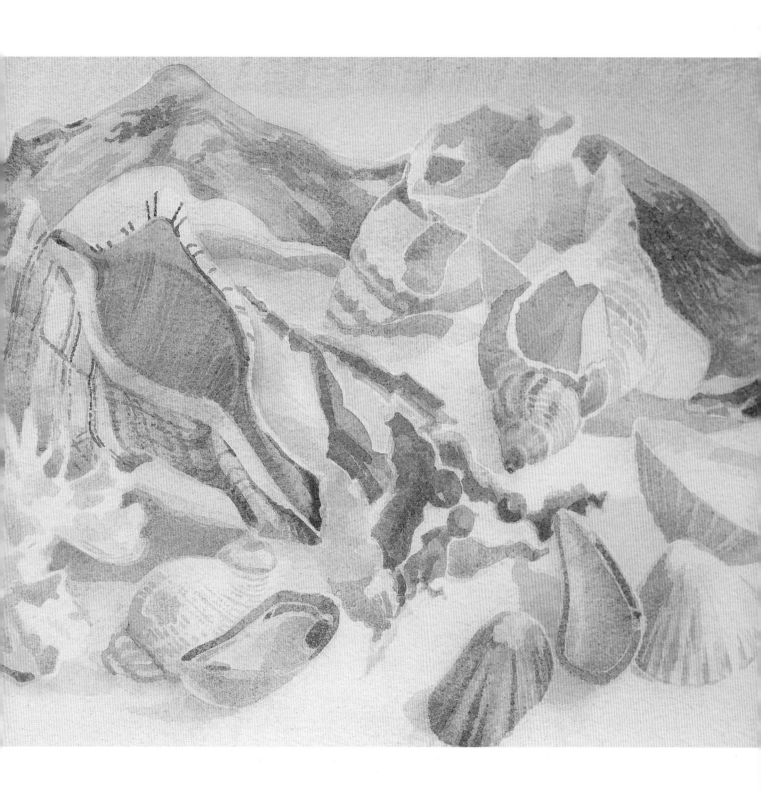

This shell study is part of the planning for another painting. It is squared for freehand transfer (a square at a time) to a larger sheet. The textures were explored with a combination of pencil shading, brown and sienna ink and line and watercolour. I also like to use the preliminary study to work out tonal values. The colour can be developed in the larger work that follows.

The small driftwood study below is for a landscape foreground, while the pen drawing of teasels on the opposite page explores their form and texture by linear means.

The drawing of rocks is in pencil and crayon, with watercolour used for the extraordinary lichen. Like Graham Sutherland, who derived so much of his inspiration from this area of rocky estuaries and inlets, I was aware of affinities between these close-up forms and the broader landscape of the hinterland.

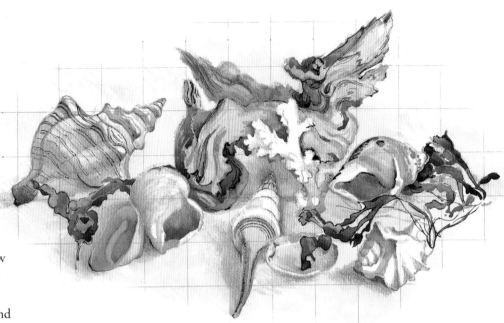

Shells. Inks, pencil and watercolour, 18 x 31cm (7 x 12in)

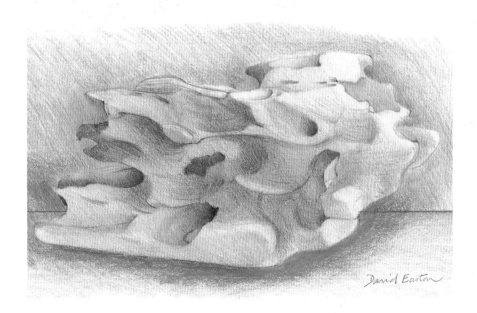

Driftwood. Crayon, 11 x 18cm (4 x 7in)

Teasels. Black ink, 21 x 26cm (8 x 10in)

Rock garden at Solva. Pencil and crayon with watercolour, 36 x 28cm (11 x 14in)

Chapter Twelve
IMAGINATION

It is perhaps a short step from using natural forms to developing more imaginative works. These paintings are derived from landscape imagery. *Three falls* is based on studies made more than a decade before, via many intermediate works. Some related sketches are shown here as well. There is clearly a considerable overlap between these particular paintings and the first painting overleaf.

Waterfall and *Round pond,* which is shown on page 114, are totally from the imagination, although some of the influence of observed natural forms persists. Both works grew organically from arbitrary first washes. *Waterfall* has moved into mixed media, with more richness of colour. *Round pond* is made of transparent washes and smaller shapes, some of which are painted wet-in-wet. The first action was to flood on a light mauve and blue wash, divided by the areas of white, which remained dry throughout.

Fall. Mixed media on handmade Arches paper, 28 x 28cm (11 x 11in)

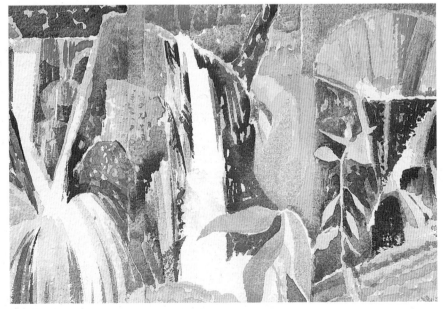

(Right) *Three falls.* Watercolour on handmade Arches paper, 28 x 41cm (11 x 16in)

(Opposite page) *Waterfall.* Watercolour and gouache on handmade Arches paper, 23 x 15cm (9 x 6in)

Both these and most of the other sketches on pages 112–115 are on handmade Arches paper. A significant part of the motivation for these works came from trying out the paper and the ready-made small format. I only use this type of work occasionally, but it is pleasant to change my approach and it does give some pleasing results.

PAINTING FROM A PAINTING

October flowers, shown on the opposite page, was produced from another more conventional painting in conjunction with a still life. The general arrangement was maintained, but the approach was built around a free-flowing set of linear brushmarks which created a totally new interpretation.

Painting from a painting is an experience that can free the artist from some of the constraints of a direct study as it facilitates a more intuitive enjoyment of colour, shape and the flow of the brush. We all have paintings with the germ of an idea that could be used as a new starting point. This technique was used by many of the great masters.

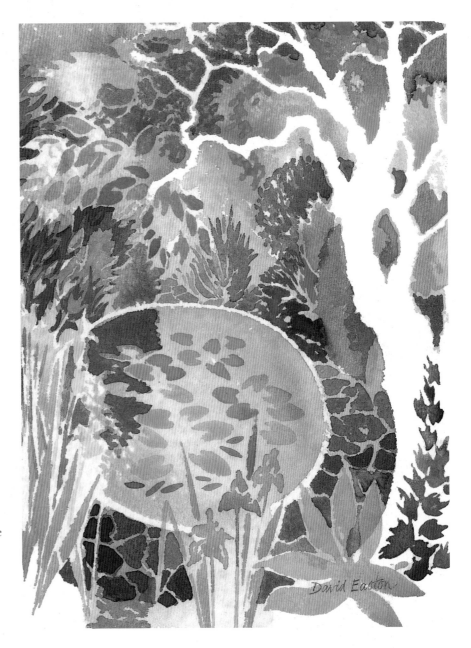

Round pond. Watercolour on handmade Arches paper, 23 x 15cm (9 x 6in)

(Opposite) *October flowers.* Watercolour and gouache, 66 x 51cm (26 x 20in)

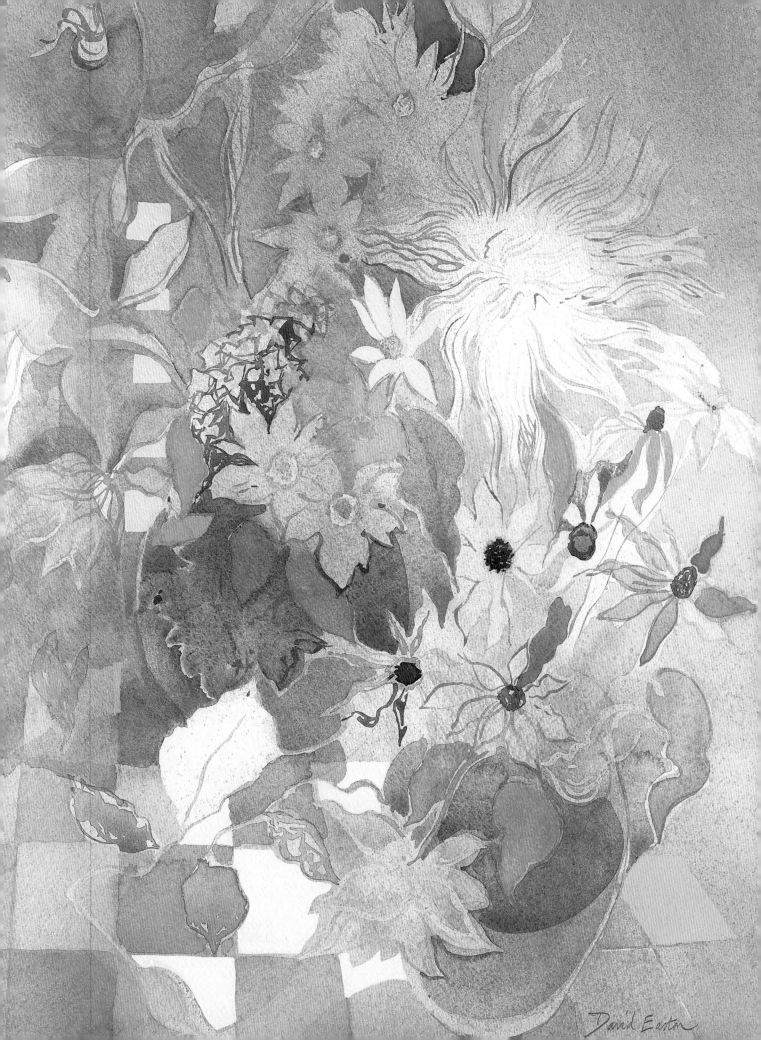

David Easton

Chapter Thirteen
COMPOSITION

Composition is the word used to describe the overall arrangement of a work of art. It applies to painting and drawing in much the same way as to written works, music, architecture, photography and sculpture.

Any painting requires a design or structure to enable the viewer to respond to its qualities. Artists use compositional devices to help the viewer to read their paintings and this involves organizing the lines, shapes, tones and colours within the rectangle to make a coherent whole.

LINEAR COMPOSITION

This is often the first stage in the making of a painting. Pencil, pen or brush lines help to set up rhythms and define key areas. These can be continuous or broken lines as well as arcs, dots and dashes for instance, which move the observer's eye through, across or (by means of perspective) into the work. Lines will draw attention to the picture plane, that is to the surface rather than to spatial depth. Within the conventions of art, however, varied weights of line can be used to suggest depth, while other elements such as tone and colour support the illusion. When making quick notes or developing ideas for paintings, linear drawings have both advantages and limitations.

TONAL COMPOSITION

An artist making a tonal composition is responding to light and shade and to the local colour and tone of the motif. This involves observing the shapes and blocks in gradations of light or dark. Balance is more obvious than with line alone.

It is useful to make tonal sketches to aid the organization of tone within the rectangle. Use a medium which will enable you to make broad marks quickly. The relationship between tone and colour is highlighted by narrowing the eyes to eliminate detail. You can then see how tones join the elements of the subject together, causing individual objects to lose their separate identity. The eye is naturally drawn to areas where the lightest and darkest tones meet.

COMPOSITION AND FORMAT

Whenever you produce a painting, you start with a decision about the format. But do you limit yourself just to conventional portrait or landscape? I have a selection of viewfinders designed to enable me to focus not only on these conventional formats, but also on squares and double squares. This allows me to look at different options when working from observation. Quick compositional sketches can be invaluable before this

choice is finalized. However do not use unusual formats without being sure of their appropriateness; the 2:3 proportion is commonly used because it is often convenient.

COMPOSITION IN LANDSCAPE

It is for landscape work that the viewfinder is most useful. It is easy to be overawed by the impact of a broad vista or to miss out on the potential of something closer at hand.

The position of the horizon, or eye level, is the subject of the first sketches. In these, and the diagrams that follow, I have shown a familiar compositional division, and then, where there may be potential problems, I have suggested alternatives. They are designed to give you ideas rather than to give failsafe answers; it is not possible to classify the success of original compositions.

In figure A the horizon is set halfway. This is a static division and the work does not focus decidedly on either the sky or the landmass. It is not a promising start, but it could be made to work if the horizon line is disguised, so that the tonal areas are less equally balanced. Attention is thereby drawn away from the horizon line by the tonal arrangement.

Both the examples show how light from the sky can be brought into the landmass, and elements of the

Figure A

Figure B

Figure C

landscape (trees and buildings) can break up the sky area. A strong shift of tone is shown from side to side across the sky, giving a focus and interest to the upper two-thirds of the picture. Figure B has a low horizon, and you will therefore need to create interest in the sky, as it is the central motif. In figure C, the high horizon gives a lot of scope for foreground interest and for making journeys into or across the terrain.

Vertical or horizontal divisions across the picture plane are of equal importance. In the conventional landscape format (where width is greater than depth) these intervals can set up a variety of visual rhythms. A common fault seen in figure D is to divide the width into equal parts. The central placing splits the picture in half and gives it a static quality. Other equal divisions add to the problem.

The other two sketches vary just a little from the symmetrical design of the first. They remain stable while giving more variety to the overall shape, and consequently to the negative spaces as well.

The composition with 'stage curtains' – figure E – is a useful device to lead the eye into the space beyond, but the two sides should be made to differ in terms of area. Having invited the viewer into the heart of the picture, a more distant focus of interest is needed.

Figure F shows two competing features – the church and the tree.

The eye has no means of escape and will bounce between them until a third element is introduced. It would be better to give one of the competitors more importance with size or with tone.

The series of diagrams in Figure G deals with another set of compositional devices. Sometimes the visual journey in a painting has an obvious direction such as a path, road or waterway, the placing of which will also divide the rectangle. These are often diagonal directions and, whether straight or curving, they are a useful foil to the occasional vertical and the many horizontals of the landscape. Avoid leading to a corner and make a point of allowing any long features to vary in tone or to fade away and then emerge in response to the lie of the land.

I would remind you again that these are very broad categories. There are many landscapes that do not fit exactly into any one of them. The principles discussed, although proved

to be successful, should not limit your use of other options.

Regard this section as a reference and build on it with your own findings. Look for something which is a focal area or an interesting relationship between the natural landscape and the man-made environment. Large shapes give strength to a composition; flat and distant tracts of open countryside can be difficult to interpret.

I strongly recommend that you try out some of these tonal landscape roughs in your sketchbook. Include a few alternative compositions on the same page. It can make a refreshing change from the more detailed drawings, and refocus your attention on the salient points of composition.

Figure D

Figure E

 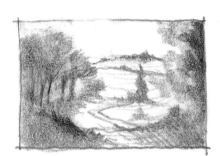 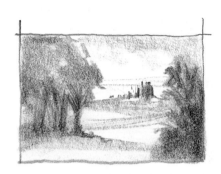

Figure F

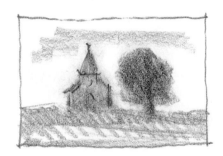 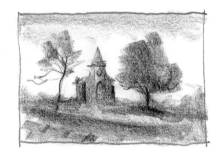 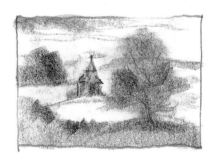

Figure G

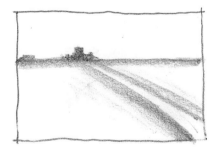 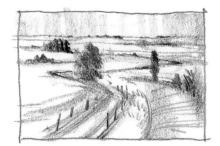 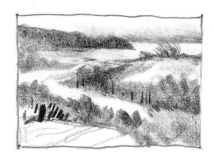

Chapter Fourteen

MATERIALS AND EQUIPMENT

You can take up watercolour painting with relatively little equipment and expense. The basic requirements, however, are:

- A sketchbook, and sheets of watercolour paper for use with a drawing board.
- A watercolour paintbox with good deep palette space, and a set of artists' quality colours.
- Two or three sable or synthetic brushes, sizes around 4 and 7, plus a larger wash brush.
- Drawing pencils and pens.
- A water jar and rags or tissues.
- A stool for location work.

WATERCOLOUR PAPERS

The recommended support for watercolour paintings is the paper or board that is designated watercolour paper. This can be obtained in sheets, of which the usual dimensions are 56 x 76cm (22 x 30in). This is usually the most economical way to buy the paper, but books or blocks may be more convenient for location work. The three types of watercolour paper are:

- Rough, which suits open, vigorous styles and enhances granular effects.
- HP, or hot pressed, which has a smooth surface, with only a slight 'tooth'.
- NOT or cold pressed, which has a texture suitable for a very wide

range of work and is consequently the most commonly used. The most popular weight of these papers is 300gsm (140lb), which would usually need to be stretched for large or for very fluid work.

Some papers are also available in tints. Pastel and cartridge papers are worth using for watercolour, as long as you realize that they will not take very watery washes. The products of each paper-mill vary in the textures and the whiteness. Prices are higher for the better qualities, reflecting the content and degree of hands-on care in their production. When you are starting out I advise the purchase of a few sheets of NOT. The characteristic that I have come to value most is hardness of surface. This quality enables work to be lifted out when necessary and it gives a greater crispness to washes.

Stretching papers

You will need to stretch papers on to a board when working with broad washes, on large sheets, or on light weights of paper. The boards should be about 10cm (4in) larger than the paper (5cm (2in) all round). I cut mine from various grades of plyboard, doing several at a time. The procedure is to lay the paper on the board and cut four pieces of 5cm (2in) wide brown gumstrip (not self-adhesive tape) for

the edges, allowing an overlap at each corner.

Then immerse the paper in cold water until it is thoroughly soaked. The timing is not critical; I have left papers in a bath for five minutes or for up to an hour depending on their weight and absorbency. Lift the wet paper carefully out of the bath and allow the surface water to drain off until it stops dripping. The sheet will still be very wet. Next lay it carefully on the board and quickly wipe excess water from the edges with a clean rag or blot it off with a tissue.

Then dampen the gumstrip pieces and press them firmly in position around the paper. I tend to make a point of dealing with any long edges first. Ideally the gumstrip should overlap the paper by about half of its width to give a good chance of adherence to both paper and board. You need to work quite quickly in order to fix the paper before the stretching begins.

Always lay the board flat until the sheet is dry. Never try to accelerate the drying by means of heaters or fans. Keep an eye on the boards from time to time as the paper dries. It may form waves as the stretching takes place. If the strip lifts away from the paper at any point, use thumb tacks to keep it secure. There are other paper-stretching products on the market

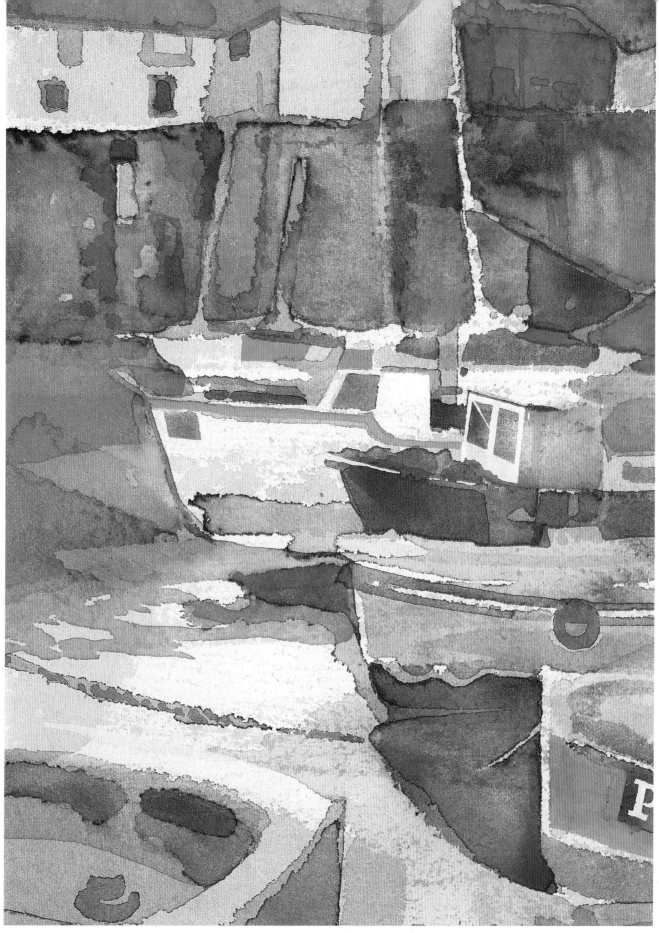

Old harbour, Newlyn. Watercolour, 29 x 20cm (11½ x 8in)

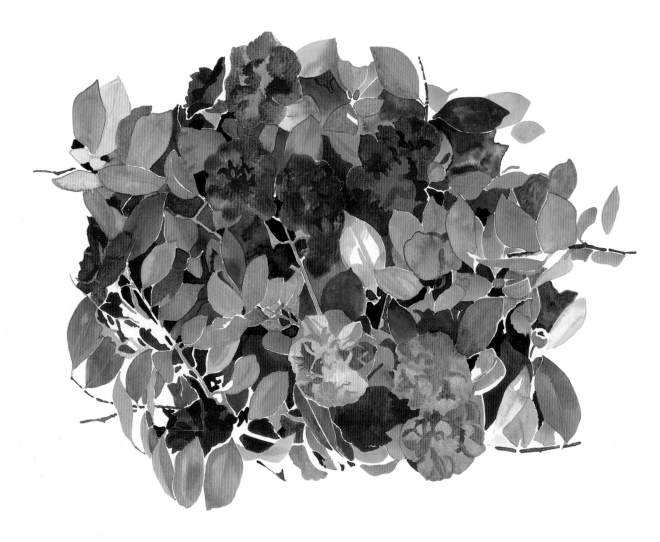

Camellias. Watercolour and gum arabic on HP paper, 31 x 38cm (12 x 15in)

and I understand that they can be effective for smaller formats.

Paints

There are two types of watercolour – cakes and tubes. The cakes or pans are obtainable in artist's or student's quality. When you wish to use a box of pans, it is advisable to choose the artist's range from one of the leading makers. These moist colours respond quickly to the brush, yielding a satisfying amount of pigment. Pans of student's quality may prove hard to work up, and tend to produce disappointingly thin washes. Tube colours are especially useful for large-scale work.

When buying your first palette, you could consider some of the starter sets. These may be good value, but avoid those which include too many earth colours, along with black, Chinese white and perhaps a brush or two. This is false economy. You are unlikely to need black; some of the earth colours are expendable; and you should choose all your brushes with care. Alternatively, you may prefer to get an empty box and fit it to your own requirements. For information on the most useful colours, refer to pages 26–7.

Transparency

The most important quality of watercolour paint is transparency. All colours are transparent when diluted with water, though some are not so clear in usage. We have seen that the basic and traditional method of using watercolour is to lay a series of washes, allowing the paper to shine through and the colours to combine visually. The value that you put upon

the clarity of your transparent colours will influence your choice of pigments. My palette, as seen on page 26, is predominantly light, but includes some colours with density. There are certain colours you could avoid using in order to keep your work translucent. The best way to achieve this is to use all your pigments in a fluid manner. There are some additives that can help. Gum arabic can be added to the mix to give brilliancy, greater transparency and even a touch of gloss. The sketch of camellias on the left features some areas where this has been used.

Opacity

The more dense and opaque pigments include mainly yellows, warm reds and oranges, and some earth colours. I find these characteristics useful. In my palette they are: lemon yellow (nickel titanate), Naples yellow, cadmiums yellow, orange and red, yellow ochre, indigo (which I use only rarely), and cerulean blue.

You will see from a number of the paintings in this book that I am not averse to using opacity, while still emphasizing the transparent nature of watercolour. The important thing is to make the use of paint reflect the subject.

Granulation

Pigments, when ground and mixed with the soluble gums, remain separate in tiny granules. These particles of pigment settle into the crevices of the paper to give the effect known as granulation.

The effect of granulation is obviously more marked on rougher papers. It is also more evident with certain colours and combinations of colours. The individual pigments that

have this characteristic are mainly on the cold side of spectrum, for example blues, violets and greens. Raw umber and raw sienna are two earth pigments that granulate.

Staining

It is useful to know which of your colours will make indelible marks on the paper. The way to find out is to paint small swatches of each on a scrap of paper and then wash them off. Paint two sets, one to wash off straight away and one to dry before washing off. This will show you which colours you will be able to lift out. It may also give you ideas about the positive use of the staining colours, perhaps for use when working with resists. This staining applies to brushes and clothes, as well as to paper, so beware!

Permanence

Most of the pigments produced by the major manufacturers are permanent. Of those mentioned in this book, alizarin crimson is only moderately durable, but there is a permanent alizarin crimson available.

The conservation of all artworks is important. Watercolours should not be hung in direct sunlight as they are subject to change over time, and light can affect the paper as well as the pigments.

Watercolour Brushes

The purpose of brushes is to transfer the washes, shapes, lines and touches of pigment to the paper with a degree of control. Unless you are a miniaturist, or seeking to paint with very fine detail, you do not need tiny brushes. Most artists do possess one

small pointed sable, but seldom use it. The really useful types to have are:

- Pointed sables (or synthetic mixtures) of sizes around 4 and 7.
- A large (10 to 14) pointed synthetic, or sable mix, is a good alternative to the larger sables, which are very expensive.
- A wash brush, in soft hair, such as ox. Chinese brushes are an option.

These should suffice, and in time you might add chisel or one-stroke sables, mixtures, or ox-hair brushes with widths of about 3mm (⅛in) and 12mm (½in).

Wash your brushes out in clean water after use and lay them flat to dry or stand them on their handles. Do not leave them standing on their points in water or they will soon get a permanent wave. Also, avoid keeping them in airtight containers for long periods as they may become mildewed. When buying a pointed brush you should ask for a clean water pot so that you can test that it makes a good springy point.

(Overleaf) *Swans*. Watercolour, 23 x 33cm (9 x 13in)

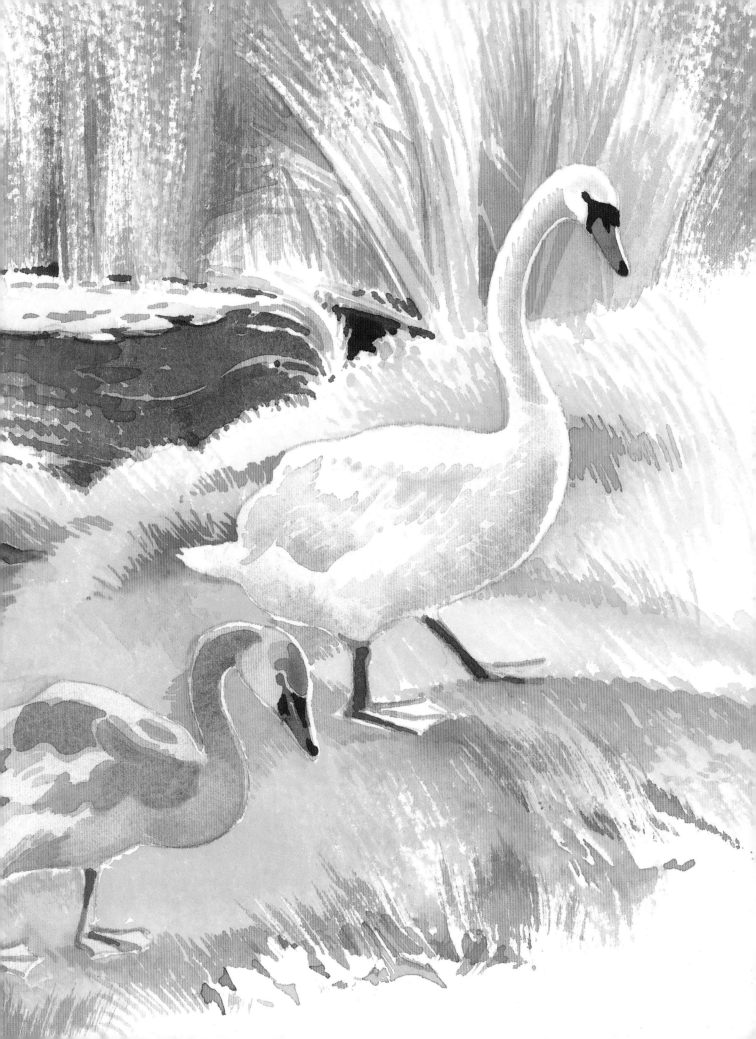

Useful Addresses

UK

Winsor & Newton
51 Rathbone Place
London W1

Caran d'Ache
Jakar International Ltd
Hillside House
2–6 Friern Park
London N12 9BX

East London Graphics
86–99 Upton Lane
London E7 8LQ

London Graphic Centre
16-18 Shelton Street
London WC2

UDO City
69–85 Old Street
London EC1V 9HX

Cornelissens
105 Great Russell Street
London WC1B 3RY

Artworks
28 Spruce Drive
Paddock Wood
Lightwater
Surrey GU18 5YX

Pullingers Stationers
109 West Street
Farnham
Surrey GU9 7HH

Hearn & Scott
10 Bridge Street
Andover
Hampshire SP10 1BH

R S Frames
4 Broomfield Road
Sunbury-on-Thames
Middlesex TW16 6SW

Broad Canvas
20 Broad Street
Oxford OX1 3AS

Daler-Rowney
PO Box 10
Bracknell
Berkshire RG12 8ST

Gemini Craft Supplies
14 Shakespeare Street
Newcastle upon Tyne
Tyne & Wear NE1 6AQ

James Dinsdale Ltd
22–4 King Charles Street
Leeds LS1 6LT

Merseyside Framing
 & Arts Ltd
62–4 Wavertree Road
Liverpool L7 1PH

John E Wright & Co
15 Brick Street
Derby DE1 1DU

Everyman
13 Cannon Street
Birmingham G2 5EN

Rod Waspe
11–13 Bank Street
Rugby CV21 2QE

Colemans
84 High Street
Huntingdon
Cambs PE18 6DP

Windsor Gallery
167 London Road South
Lowestoft
Suffolk NR33 0DR

Doodles
61 High Street
Newport Pagnell
Bucks MK16 8AT

Framework
63 Pembroke Centre
Cheney Manor
Swindon
Wiltshire SN2 2PQ

Dicketts
6 High Street
Glastonbury
Somerset BA6 9DU

Mair & Son
46 The Strand
Exmouth
Devon EX8 1AL

CJ Graphic Supplies Ltd
32 Bond Street
Brighton
Sussex BN1 1RQ

Forget-Me-Not
70 Upper James Street
Newport
Isle of Wight P030 1LQ

Elsa Frisher
9 St Peter's Square
Ruthin
Clwyd LL15 1DH

Inkspot
1–2 Upper Clifton Street
Cardiff
South Glamorgan CF2 3JB

Alexander's Art Shop
58 South Clerk Street
Edinburgh EH8 9PS

Burns & Harris
163–165 Overgate
Dundee DD1 1QF

Millers Ltd
11–15 Clarendon Place
St George's Cross
Glasgow G20 7PZ

The EDCO Shop
47–49 Queen Street
Belfast BT1 6HP

W F Gadsby Ltd
22 Market Place
Leicester
LE1 5GF

USA

Aiko's Art Materials
Import
3347 N. Clark Street
Chicago
Illinois 60657

Badger Air-Brush Company
9128 West Belmont Ave
Franklin Park
Illinois 60131

Fletcher-Lee & Co.
PO Box 007
Elk Grove Village
Illinois 60009

Printmakers Machine Co.
PO Box 71
Villa Park
Illinois 60181

Pearl Paint Company
307 Canal Street
New York 10013

New York Central
 Art Supply
62 3rd Avenue
New York 10003

Artist's Connection
20 Constance Ct
PO Box 13007
Hauppauge
New York 11788

Winsor & Newton
PO Box 1396
Piscataway
New Jersey 08855

The Italian Art Store
84 Maple Avenue
Morristown
New Jersey 07960

Art Supply Warehouse
360 Main Avenue
Norwalk
Connecticut 06851

The Artist's Club
5750 NE Hassalo Street
Portland
Oregon 97213

Texas Art Supply
2001 Montrose Boulevard
Houston
Texas 77006

Sax Arts and Crafts
PO Box 51710
New Berlin
Wisconsin 53151

Perma Colour
226 E Tremont
Charlotte
North Carolina 28203

Co-Op Artist's Materials
PO Box 53097
Atlanta
Georgia 30355

Chroma Acrylics Inc.
205 Bucky Drive
Lititz
Pittsburgh 17543

Conrad Machine Co.
1525 S. Warner
Whitehall
Michigan 49461

HK Holbein Inc.
PO Box 555
Williston
VT 05495

Ziegler
PO Box 50037
Tulsa
Oklahoma 74150

Art Express
1561 Broad River Road
Columbia
SC 29210

Pentel of America Ltd
2805 Columbia Street
Torrance
California 90503

Napa Valley Art Store
1041 Lincoln Avenue
Napa
California 94558